50 Nifty Collage Cards

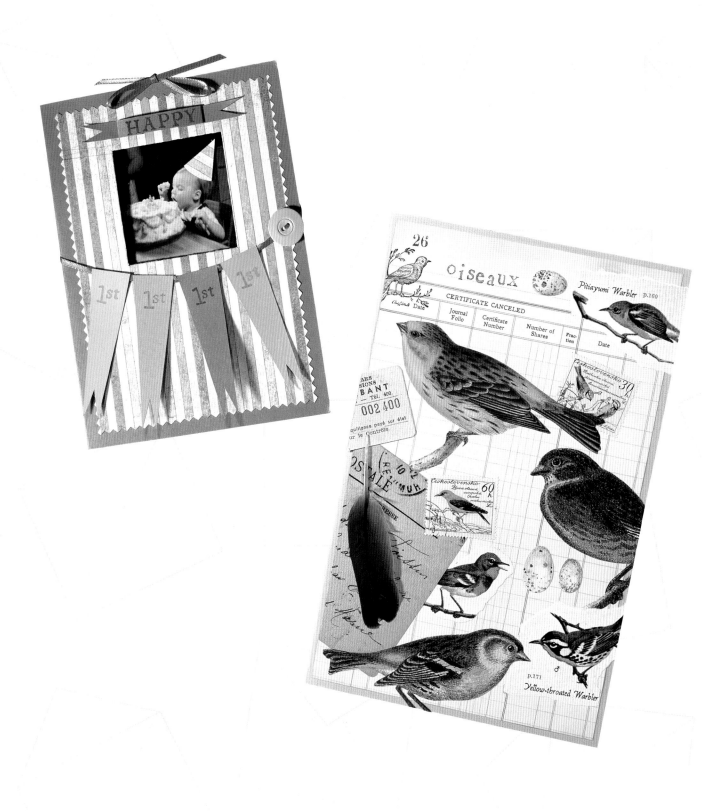

50 Nifty Collage Cards

Peggy Jo Ackley

LARK BOOKS

A Division of Sterling Publishing Co., Inc.
New York / London

EDITOR
Linda Kopp

ART DIRECTOR
Kristi Pfeffer

COVER DESIGNER
Cindy LaBreacht

ASSISTANT EDITORS
Mark Bloom, Cassie Moore

DESIGN ASSISTANT
Avery Johnson

**ART PRODUCTION
ASSISTANT**
Jeff Hamilton

ILLUSTRATOR
Peggy Jo Ackley

PHOTOGRAPHER
John Widman

For Mom, Dad, Fred, and Max, who each gave me their love and encouragement.

Library of Congress Cataloging-in-Publication Data

Ackley, Peggy Jo.
 50 Nifty Collage Cards / Peggy Jo Ackley. -- 1st ed.
 p. cm.
 Includes index.
 ISBN-13: 978-1-60059-121-1 (pb-trade pbk. : alk. paper)
 ISBN-10: 1-60059-121-3 (pb-trade pbk. : alk. paper)
 1. Greeting cards. 2. Collage. I. Title.
 TT872.A335 2008
 745.594--dc22
 2007026096

10 9 8 7 6 5 4 3 2 1

First Edition

Published by Lark Books, A Division of Sterling Publishing Co., Inc.
387 Park Avenue South, New York, N.Y. 10016

Text © 2008, Peggy Jo Ackley
Photography © 2008, Lark Books
Illustrations © 2008, Peggy Jo Ackley
Distributed in Canada by Sterling Publishing,
c/o Canadian Manda Group, 165 Dufferin Street
Toronto, Ontario, Canada M6K 3H6

Distributed in the United Kingdom by GMC Distribution Services,
Castle Place, 166 High Street, Lewes, East Sussex, England BN7 1XU

Distributed in Australia by Capricorn Link (Australia) Pty Ltd.,
P.O. Box 704, Windsor, NSW 2756 Australia

If you have questions or comments about this book, please contact:

Lark Books
67 Broadway
Asheville, NC 28801
828-253-0467

Manufactured in China

ISBN 13: 978-1-60059-121-1

ISBN 10: 1-60059-121-3

For information about custom editions, special sales, premium and corporate purchases, please contact Sterling Special Sales Department at 800-805-5489 or specialsales@sterlingpub.com.

Contents

Introduction . 6
Basics . 7

COLORS
Yellow Birds 14
Pink Lady. 16
Patchwork Window. 18
Sailor Boy . 20
Roman Statues 22
French Perfume Labels. 24
Precious Metals 26
Orange Grove 28

FOCAL POINTS
Vanilla Bean 32
Organ Grinder 34
Señorita. 36
Golden Pears. 38
Florentine Queen 40
Acme Soap Girl. 42

PHOTOGRAPHS
Beehive Girls. 46
Birdhouse Sisters 48
Birthday Flags. 50
Empress Dowager 52
Ivory Gown 54
Dog Biscuits 56
Our House. 58
Back to School 60

EMBELLISHMENTS
Pink Cake . 64
Song Bird. 66
Rooster Tag 68
Bay of Biscay. 70
Letter in Hand 72

Queens of the Theater 74
Les Lapines 76
Baby Buttons 78

THEMES
Elephantus 82
Oiseaux. 84
Polka Dot Circus 86
Harvest Party 88
Sailing Ships 90
Lepidoptera. 92
Venezia . 94
Petunia Packet 96

BACKGROUNDS
Japanese Ladies 100
Shakespeare's Map 102
Dress Pattern 104
Rose Boxes 106
Mi Familia 108
Blue Willow Bear 110
Cerises . 112

INSIDE TREATMENT
Japanese Ladies 116
Golden Pears. 118
Pink Lady. 119
Oiseaux. 120
Song Bird. 122
Dog Biscuits 123

Templates 124
Author Bio/Acknowledgments 127
Index . 128

Introduction

Handmade cards are a treat for both the giver and the receiver. They tell the recipient that you cared enough to make it yourself, and that it came from your heart. Making cards by hand is extremely satisfying, and using collage techniques can truly make them pieces of artwork. As many fine artists have discovered, the process of making a collage can be just as important as the final product. It's a satisfying way to arrange personal bits and pieces from your life, and with practice and observation, you will develop a knack for placement that feels right for each piece.

The 50 projects in this book provide a wonderful way to use those materials such as photographs (both old and new) and scraps of decorative paper that we all seem to collect. Start saving items that catch your eye: magazine clippings, sheet music, old textbooks, tickets, cancelled stamps—anything that you think might make interesting layers. Sometimes these pieces can sit around for ages before the right composition comes, but when it does—bingo—you've got the perfect addition! Along with using paper embellishments, some of the projects presented here use rubber stamps to create great graphic elements, backgrounds, and accents. Others make use of trinkets, charms, ribbons, and trims to add depth and richness to a card.

When you start making the projects, you'll find it's much easier to add to a collage than to take elements away. Start with a few images spaced apart from each other, then begin filling in. Arrange and rearrange but remember that each time you add or remove elements, you change the composition. So don't glue or tape anything down until you are satisfied with its placement. Collaging is a relaxing and fun process where "mistakes" can be serendipitous and lead to unexpectedly rewarding results. You'll be pleasantly surprised by how easy it is to make cards you're proud to give away.

Basics

TOOLS AND SUPPLIES

Collaging is a wonderful way to use the packaging, papers, notions, and found objects you encounter every day. Because the materials you find will differ, your cards, of course, won't look exactly like the projects in the book, but that's what will make each card unique. Before you sit down to begin cutting and pasting, gather together your collaging "tool kit"—the essential items that you'll need for most any card design in this book.

TOOL KIT

Adhesives (see below for types)
Scissors (standard sharp pair and decorative-edged like deckle, scallop, stamp-edged, and pinking shears)
Mat or craft knife
Bone folder
Ruler (12-inch [30.5 cm] metal)
Pencils (regular and colored)
Brayer

Adhesives

I used six basic adhesives to create the cards in this book. You will need different adhesive types depending on which card you choose to create. Check the individual card instructions for the specific ones required.

Glue stick — Use this for all basic paper-to-paper gluing. I like to apply the glue from the center of the paper outwards, running it off the edges.

Craft glue — Thin it with water and brush it on to smaller pieces of paper when creating a "mosaic" effect. On larger surfaces, craft glue can have a tendency to buckle.

Industrial strength glue — This is a heavy-duty adhesive that I use for attaching larger dimensional objects such as buttons, beads, charms, fabric leaves, etc.

Bonding glue — Used with a fine-tipped applicator, this glue is perfect for attaching tiny dimensional objects like seed beads or sequins. Note that bonding and industrial glues should both be used in a well-ventilated area.

Double-sided tape — Use for thick or textured papers and flat embellishments that require more holding power than a glue stick can offer.

Adhesive foam dots or tape — These are perfect for creating depth on a card, as they raise an image above its background. Foam tape pieces can also be stacked on top of one another for even greater dimensionality.

TIP

I use mail order catalogs and magazines for my gluing surface. Once the working surface gets too messy, just turn the page for a fresh sheet and recycle when you're done!

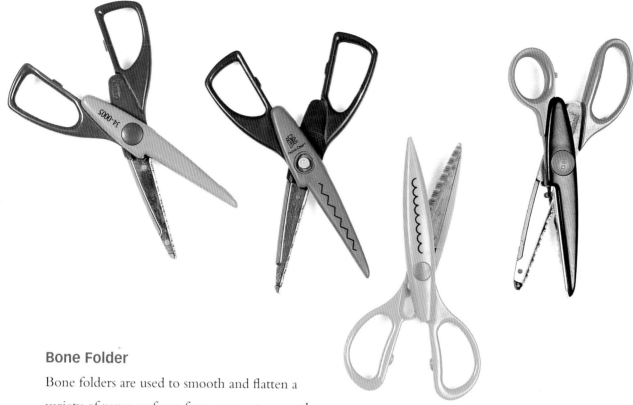

Bone Folder

Bone folders are used to smooth and flatten a variety of paper surfaces, from creases to recently glued surfaces.

Decorative-Edged Scissors

Decorative-edged scissors are great craft tools that can add instant pizzazz to any paper with just a snip.

Brayer

A brayer is typically used to spread ink in a printing process, but it is utilized in this book to smoothly flatten papers, ribbons, and images to ensure that they are securely attached.

Mat or Craft Knife

Mat and craft knives are perfect for trimming paper and making exacting cuts.

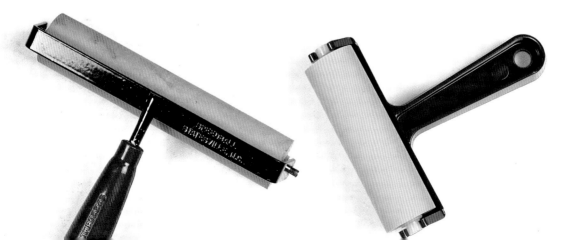

TECHNIQUES

While collage at its purest form is defined as "a picture made by sticking cloth, pieces of paper, photographs, and other objects onto a surface," there are some simple techniques that will enhance your collaging experience, while adding interest and a professional finish to your cards.

Embossing

Embossing adds a slightly raised surface to a stamped design. To emboss, you will need a rubber stamp, embossing powder, an embossing pad or pen, and a heat gun.

1 Working on top of a folded piece of scrap paper, use embossing ink to rubber-stamp an image onto your card's surface, or draw an image with an embossing pen.

2 Sprinkle the entire stamped or drawn area with embossing powder. Carefully tap the excess powder onto the folded scrap paper and pour it back into the jar.

3 If you have sprinklings of powder outside of the image, use a very small paintbrush to carefully brush them off. Don't be tempted to blow!

4 Aim the heat gun about 2 inches (5 cm) directly above the freshly powdered image. Sweep it back and forth to heat the powder until it's raised and glossy.

> **NOTE**
>
> *You may need to hold the paper down with tweezers or another tool if the surface is too hot for your fingers. The image will be dry to the touch almost immediately.*

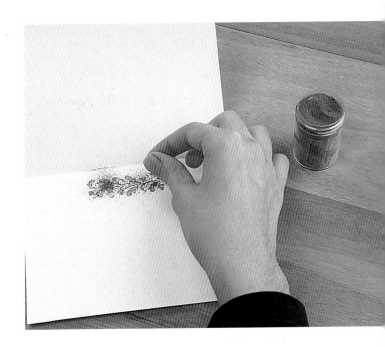

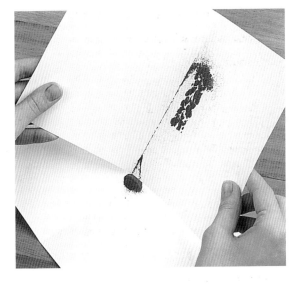

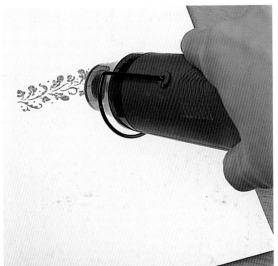

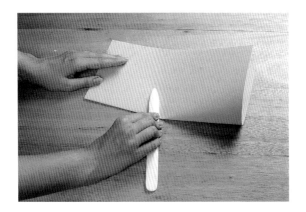

Folding

Every card in this book starts out by folding cardstock in half. To make a neat, professional fold, line up both the top and side of the card. Hold down the cardstock with one hand, and use the other to make a crisp fold by pressing down over the crease with the side of your bone folder. To prevent the card from having a shiny look, I recommend first covering the crease with a folded sheet of scrap paper before using the bone folder. If your card is a bit crooked, it can be corrected by using a mat knife and metal ruler to trim off a thin strip from the uneven side.

Scoring

Scoring a fold first can make a big difference in the neatness and accuracy of the fold. First measure carefully, then line up a metal ruler against the measurement, and run the tip of your bone folder along the fold line. This method is particularly helpful if you're making a fold against the grain of the paper.

Setting an Eyelet

Eyelets allow you to attach other materials to your card, or can be used alone as a decorative element. To set an eyelet you will need an eyelet hole punch, an eyelet setter, and a small hammer. It's best to work on a hard surface covered with some padding. I like to use an old cutting board with a magazine on top of it.

1 Start by selecting an eyelet hole punch with the same sized circle as the eyelet you plan to set.

2 Position the punch directly over the paper, and tap firmly with a hammer once or twice.

3 Push the eyelet through the hole you just made, then turn the paper surface over. If you want to attach something underneath the eyelet, be sure to push that through first.

4 Match the setting tip to the eyelet size. Position the setter directly over the eyelet's shaft, and tap firmly once or twice with the hammer.

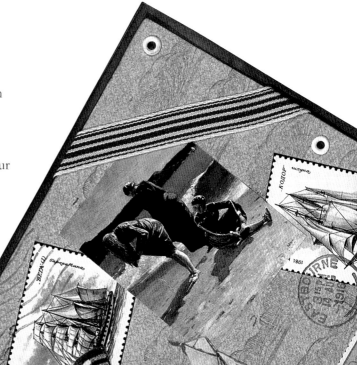

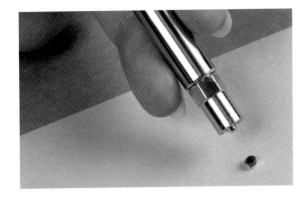

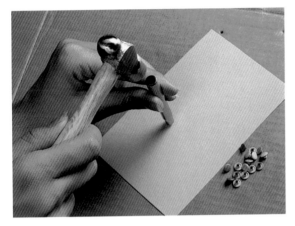

NOTE

Be sure to empty the hole punch periodically in order to punch out a clean hole. Also, don't hammer too forcefully or the eyelet shaft will splay.

Tearing Paper

Commercial papers have a definite grain. You can find the grain by hand-tearing a piece of the paper both horizontally and vertically. Whichever way the paper tears the easiest, you are tearing parallel to the grain—more difficult, against the grain. In either direction, the more natural look of a torn edge can create a beautiful collage effect. You can tear along a straight edge by first making a fold and then tearing it, or tear by hand for a more random look. When tearing by hand, I often use a pencil guideline on the back of the paper and try to allow at least a ½-inch (1.3 cm) margin on either side of the guideline. Pinch both sides of the paper with your thumb and forefinger, and with a twisting motion, make short rips. This helps to control the tear so it doesn't go awry. Practice a few times on scrap paper until you feel comfortable with the technique.

Using a Brayer

You will notice that I often refer to "rolling with a brayer" in the card directions. There are two reasons for this: the brayer helps adhere the two paper surfaces together, and it also flattens out any creases or bubbles. Be sure to select a brayer that has some "give" to it; I find a 3-inch-wide (7.6 cm) roller to be the most useful. When rolling, start from the center and work your way out to the corners, just like you're rolling out a pie crust!

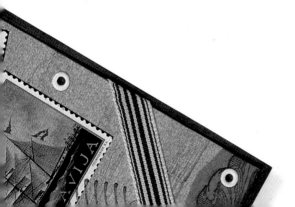

colors

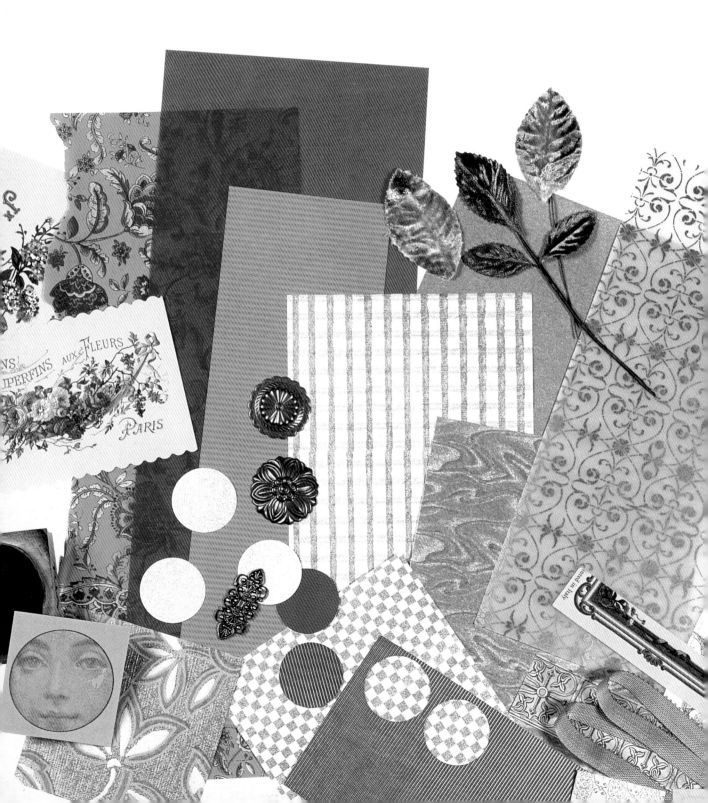

Choosing a color is a great way to begin a card. You can either start with a basic card-stock color that you love and gather pieces to coordinate with it, or begin with a favorite image and collect coordinating papers, pictures, and a unifying background color.

If you find that you can't locate the right shade or need more material, simply paint it! For example, the Parisian ticket in *Pink Lady* (page 16) was originally white, so I painted it with watercolors to make it the perfect pink. Another handy design material is a ribbon. Ribbons come in a rainbow of textures, colors, and combinations and can help tie images together. If you can't settle on just one color theme, use two complementary colors as I did in *Yellow Birds* (page 14). I was lucky to find a pretty two-toned ribbon using both yellow and lavender.

Just for fun, every now and then, try making a collage in a color that is out of your natural palette. It can be very freeing!

Yellow Birds

Birds, butterflies, pansies, and lilacs bring the complementary colors of yellow and lavender in from the garden and onto this card. By using a gatefold design, each color can be both featured and used as an accent.

MATERIALS

- 5 x 7½-inch (12.7 x 19 cm) piece of lavender cardstock
- 5 x 7½-inch (12.7 x 19 cm) piece of light yellow cardstock
- Watermark stamp pad
- Large script rubber stamp
- 2 strips of decorative lavender paper, each 7½ x ½ inches (19 x 1.3 cm)
- 12 to 14 images of birds, flowers, butterflies, tickets, etc., in shades of lavender, purple, and yellow
- 8 inches of lavender and/or yellow ribbon, ½ inch (1.3 cm) wide
- Large antique gold flower charm

■ STEP BY STEP

1 Measure 2½ inches (6.4 cm) in from one 5-inch (12.7 cm) side on each piece of cardstock.

2 Firmly glue the 5-inch-square (12.7 cm) section of light yellow cardstock on top of the 5-inch-square (12.7 cm) section of lavender cardstock and roll with the brayer. You should have a 2½-inch-wide (6.4 cm) lavender flap on the left and a 2½-inch-wide (6.4 cm) yellow flap on the right.

3 Score and fold each 2½-inch (6.4 cm) flap inwards so that they align in the center, creating a gatefold.

4 Use the watermark pad to ink the script rubber stamp, and stamp onto each side of the gatefold flaps, aligning the script as best as possible from edge to edge.

5 Glue a ½-inch-wide (1.3 cm) decorative lavender strip to each center edge of the gatefold.

6 Carefully cut out the floral and bird images. Feel free to tear around some of the smaller or more intricate images. Arrange them so they are scattered down each side of the card, overlapping some. Glue them down and roll the entire surface with your brayer. Trim off any images that hang over the edges.

7 Loop the ribbon over on itself, and tape down with small pieces of double-sided tape. Using industrial adhesive, glue the charm down on top of the ribbon as shown.

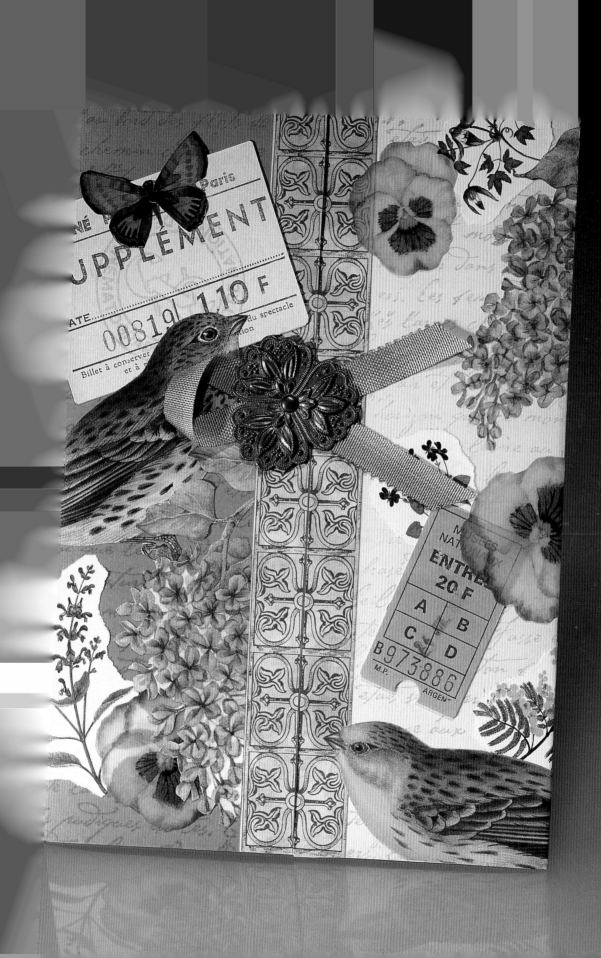

Pink Lady

From Indian prints to an antique rose, this card radiates pink. Torn and scalloped edges add layers of interest while a serene female face adds a touch of mystery to this colorful collage.

COLORS

MATERIALS

- 8 x 10-inch (20.3 x 25.4 cm) piece of hot pink cardstock
- 2½ x 8-inch (6.4 x 20.3 cm) piece of hot pink vellum
- 2½ x 8-inch (6.4 x 20.3 cm) piece of hot pink cardstock
- 4½ x 8-inch (11.4 x 20.3 cm) piece of hot pink vellum
- 4 x 8-inch (10.2 x 20.3 cm) piece of pink decorative paper
- 2 x 8-inch (5 x 20.3 cm) piece of pink decorative paper
- Black rubber stamp pad
- Rubber stamp of a woman's face
- Piece of pale pink paper large enough to stamp the face image
- Pink colored pencil
- 5 small pink-themed images such as tickets, postage stamps, etc.
- 18 inches (45.7 cm) of ½-inch-wide (1.3 cm) pink ribbon
- Vintage gold watch face or other round gold metal charm

■ STEP BY STEP

1 Fold the cardstock to make a 5 x 8-inch (12.7 x 20.3 cm) card.

2 Glue the 2½ x 8-inch (6.4 x 20.3 cm) piece of vellum onto the 2½ x 8-inch (6.4 x 20.3 cm) piece of cardstock. Fold in half and trim each long side with the large scalloped scissors.

3 Glue down the back of the folded half of vellum/cardstock strip to the back of the card spine. Leave the front half unglued for now, creating a flap.

4 Tear off one long edge of both the larger pieces of pink vellum and the pink decorative paper. Try to mimic the tear lines so they follow a similar pattern.

5 Glue the torn vellum down so that the left-hand straight edge aligns with the card spine, then roll with a brayer.

6 Glue the torn decorative paper over the vellum so that about ¼ inch (6 mm) of the torn vellum edge shows to the right of the torn paper. Roll with the brayer.

7 Trim one long edge of the 2 x 8-inch (5 x 20.3 cm) piece of decorative paper with the scallop scissors. Glue it down so that 1 inch (2.5 cm) will show beyond the scalloped spine flap. Roll with the brayer once more.

8 Using the black stamp pad, stamp the image of a woman's face onto the pale pink paper. Lightly color in her cheeks and lips with the pink colored pencil. Cut out.

9 Arrange the face, images, and postage stamps underneath the scalloped spine flap, then glue

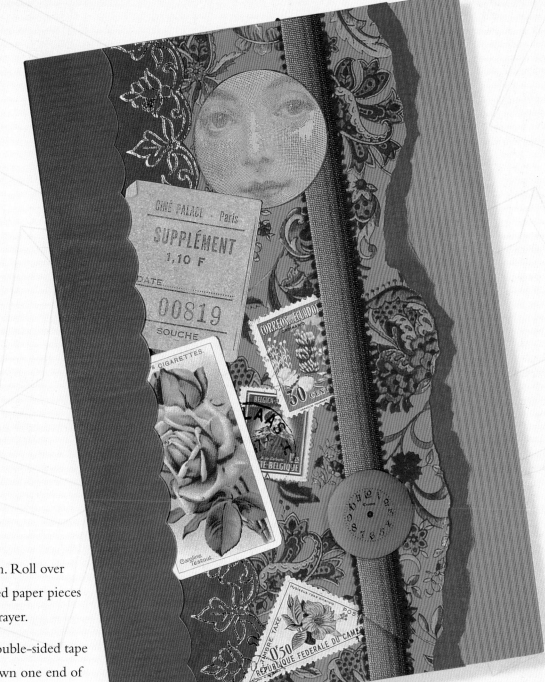

them down. Roll over all the glued paper pieces with the brayer.

10 Use double-sided tape to stick down one end of the ribbon about 2 inches (5 cm) up from the bottom edge of the card face. Wrap the ribbon around the inside of the card and tape the ends down, the second end over the first. Trim the ends at an angle.

11 Use a piece of double-sided tape to stick down the watch face or charm on top of the spot where the ribbon is taped.

NOTE

See page 119 for inside treatment ideas.

Patchwork Window

Snippets of memory in swatches of antique gold compose a patchwork design. This format of small squares is a great way to use cancelled stamps, tiny photographs, and lots of leftover paper scraps in a colorful way.

MATERIALS

- 6 x 12-inch (15.2 x 30.5 cm) piece of cardstock
- Small photo, about 2 inches (5 cm) square
- 15 scraps of decorative papers in coordinating colors, each 1 inch (2.5 cm) square
- 5 postage stamps of similar color
- 5 inches (12.7 cm) of seam binding or ribbon, ½ inch (1.3 cm) wide
- Metal charm

STEP BY STEP

1 Fold the cardstock to make a 6-inch-square (15.2 cm) card.

2 Lightly rule out a grid of 1½-inch (3.8 cm) squares on the face of the card.

3 Select which square you would like to be the photo window and, using the mat knife and ruler, carefully cut out that 1½-inch (3.8 cm) square from the face of the card.

4 Position the photo on the inside right of the card so it both shows through the window and is straight. Mark each corner with a pencil dot, and glue the photo down.

5 Arrange the paper squares and postage stamps to form a pleasing composition. One by one, glue the squares down. Try to have as little background paper exposed as possible. Glue the postage stamps down on the paper squares, and then roll all the papers with a brayer.

6 Wrap the ribbon around the edge of your card and through the window, so that both ends are on the front of the card. Tape the right end down first, and then tape the left end over it. Trim the loose end in a short "V."

7 Add a portion of industrial glue to the back of your charm, and press it directly over the taped ends of the ribbon.

NOTE

This card can be done in virtually any color and is a wonderful way to use up scraps! It is also an ideal way to feature a very small photograph. If you choose to wrap the ribbon around a different part of the card, you will need a longer length.

Sailor Boy

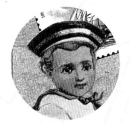

A dreamy-eyed sailor boy on the pier imagines sailing ships and crashing waves. The eyelet treatment here evokes canvas sail rivets, while the postmarks speak of faraway ports in a world of blue.

MATERIALS

- 7 x 10-inch (17.8 x 25.4 cm) piece of light blue cardstock
- Dark blue stamp pad
- 3 rubber stamps: waves and 2 postal marks
- 5 x 1-inch (12.7 x 2.5 cm) piece of medium blue cardstock
- 4¾ x 6¾-inch (12.1 x 17.2 cm) piece of light blue cardstock
- Victorian sailor boy image
- 6 nautical pictures or postage stamps
- 4 white eyelets
- Eyelet setter kit
- 2 feet (61 cm) of blue ribbon

■ STEP BY STEP

1 Fold the 7 x 10-inch (17.8 x 25.4 cm) cardstock in half to make a 5 x 7-inch (12.7 x 17.8 cm) card.

2 Use the blue stamp pad to "wipe" about ¼ inch of color all around the top, bottom, and right-hand edges of the folded card front.

3 Stamp a wave image across the 5 x 1-inch (12.7 x 2.5 cm) piece of medium blue cardstock. Trim the top of the wave piece so it follows the stamped wave edges.

4 Glue the wave paper to the bottom of the 4¾ x 6¾-inch (12.1 x 17.2 cm) piece of light blue cardstock.

5 Stamp waves and postal marks lightly over the small piece of light blue cardstock. Overlap them, but don't overdo it.

6 Using the photo as a guide for placement, glue the sailor boy, stamps, and pictures to the stamped cardstock. Roll all the pieces with a brayer.

7 Set the four white eyelets in a row along the right-hand edge of the small cardstock.

8 Wrap ribbon around the two right-hand corners of the stamped cardstock, and stick them down on the back using pieces of double-sided tape.

9 Glue the entire piece onto the larger folded card so that the inked blue edges show. Roll thoroughly with the brayer.

10 Wrap the remaining piece of ribbon around the entire card front near the spine, and stick down each end with double-sided tape, one over the other, on the inside of the card.

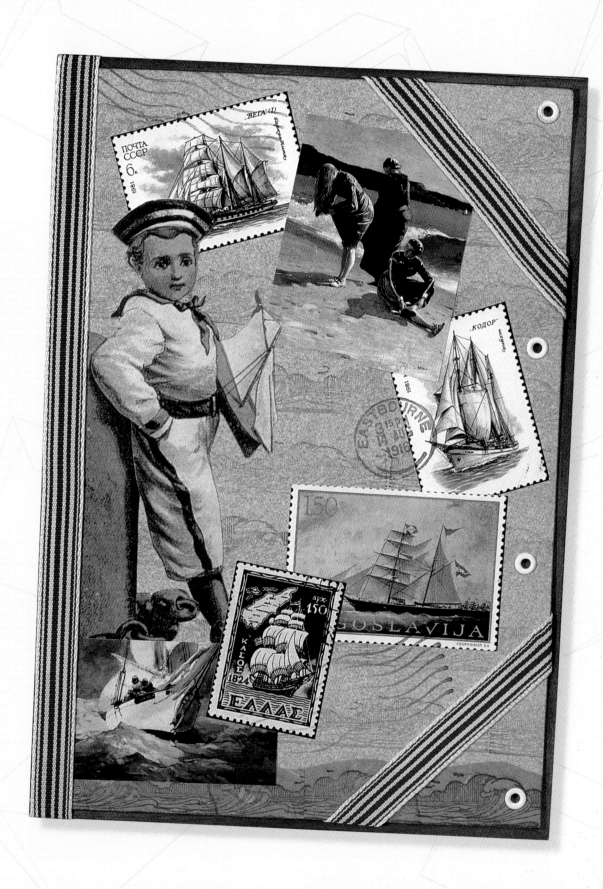

COLORS

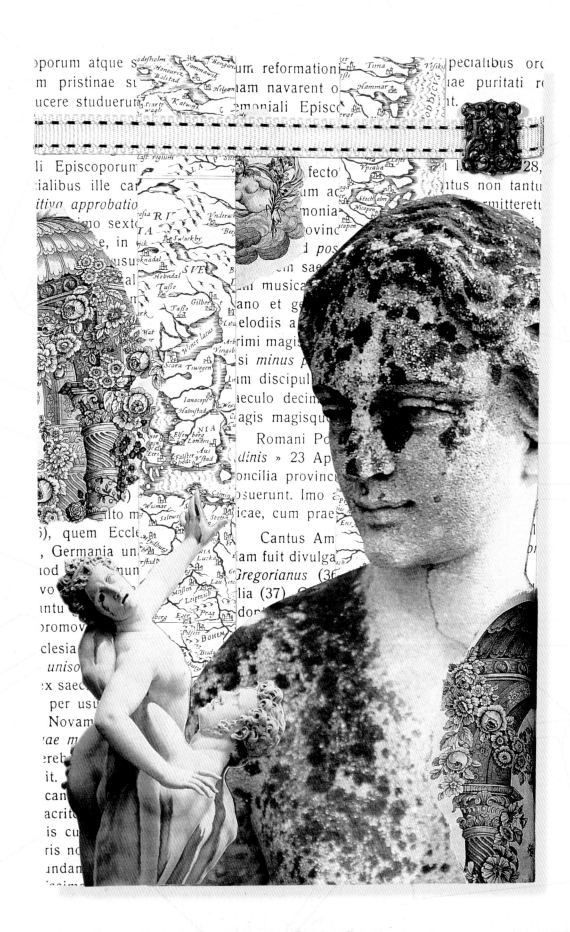

Roman Statues

Marble statues, Latin text, and antique maps create a world of antiquity for this study in black and white. The striping technique adds interest to the background while still continuing the color theme.

MATERIALS

- 8 x 10-inch (20.3 x 25.4 cm) piece of white cardstock
- 3 strips of black and white Latin text, each 1 x 8 inches (2.5 x 20.3 cm)
- 2 strips of black and white map print, each 1 x 8 inches (2.5 x 20.3 cm)
- 5 or 6 black and white images of antiquity
- 12 inches (30.5 cm) of black and/or white ribbon
- Silver metal charm

■ STEP BY STEP

1 Fold the white cardstock in half to make a 5 x 8-inch (12.7 x 20.3 cm) card.

2 Mark along the top and bottom of the card in 1-inch (2.5 cm) increments, and lightly rule out stripes with a pencil.

3 Glue down the background paper strips, alternating between the text and the map, making sure no white space shows between the strips. Roll the entire background thoroughly with a brayer.

4 Carefully cut out your black and white statuary images. Tear around any complex smaller images. Arrange the images to form a pleasing composition. Glue each one down, and roll with the brayer.

5 Measure down ½ inch (1.3 cm) on the spine of the card. Using a mat knife and a metal ruler, carefully cut a vertical ½-inch (1.3 cm) slit just behind the spine of the card.

6 Thread your ribbon through the slot so both ends come around to the front of the card. Use double-sided tape to secure the left end of the ribbon about ½ inch (1.3 cm) in from the right-hand edge of the card. Tape the right end directly over the left, and trim the end at an angle.

7 Apply a dab of industrial glue to the back of the charm, and press down directly over the taped portion of the ribbon.

French Perfume Labels

Lush flowers and French perfume labels evoke visions of Parisian shops along a grand boulevard. Decorative trim, satin ribbon, and fabric leaves each bring a touch of spring green to this feminine card.

MATERIALS

- 8½ x 11-inch (21.6 x 27.9 cm) piece of light green cardstock
- Watermark stamp pad
- Large floral background stamp
- Scalloped scissors
- 4 x 8½-inch (10.2 x 21.6 cm) piece of green patterned paper
- 8½ x ¾-inch (21.6 x 1.9 cm) strip of decorative green paper
- 11 inches (27.9 cm) of pale green satin ribbon, 1 inch wide
- 3 green floral labels
- 2 botanical stickers
- 3 postage stamps
- 3 green velvet or satin leaves
- Gold metal charm

STEP BY STEP

1 Fold the cardstock to make a 5½ x 8½-inch (14 x 21.6 cm) card.

2 Use the watermark pad to stamp the entire front of the card with the floral stamp.

3 Measure ½ inch (1.3 cm) in from the front right-hand edge, and trim with scalloped scissors.

4 Trim both long edges of the green patterned paper with scalloped scissors.

5 Fold the patterned paper vertically and glue over the spine of the card. Roll with a brayer.

6 Scallop the left-hand edge of the ¾-inch (1.9 cm) strip of decorative paper, and glue it to the right-hand edge of the inside of the card.

7 Clip an inverted "V" in each end of the ribbon and, using the project photo as a guide for placement, tape one end to the bottom of the card face.

8 Arrange the labels, stamps, stickers, and two of the fabric leaves so they are tucked under the ribbon. Glue or stick down all the items and then roll with a brayer.

9 Tape down the other end of the ribbon to the inside of the card.

10 Use industrial glue to attach the metal charm and the leaf on top of the ribbon.

COLORS

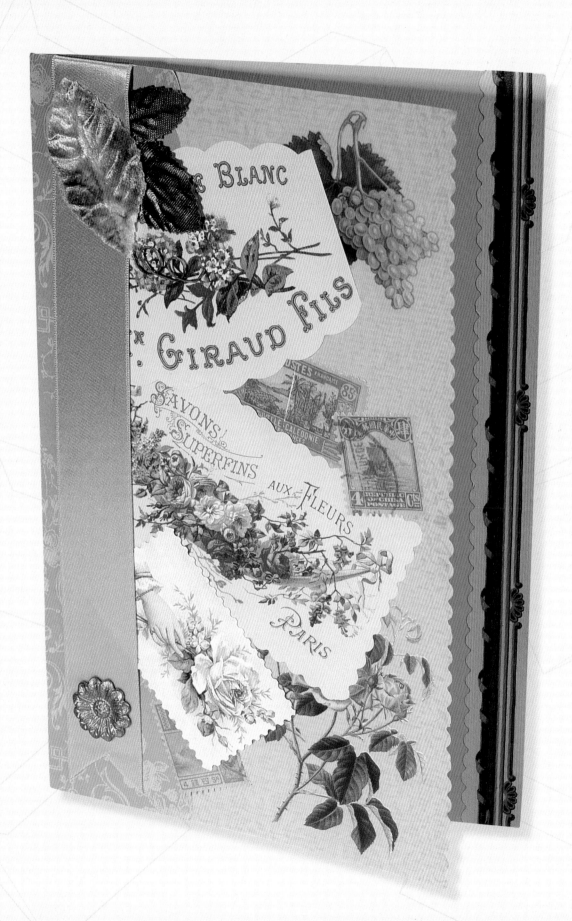

Precious Metals

The shimmer of silver and gold is layered in papers, ribbons, and metal charms. With its elaborate ribbon corner treatments and formal closure, this design would make a regal invitation or announcement.

MATERIALS

- 6 x 12-inch (15.2 x 30.5 cm) piece of white cardstock
- 4 different pieces of silver and/or gold metallic papers, each 3 inches (7.6 cm) square
- Sheet of silver cardstock
- 1-inch (2.5 cm) circle paper punch
- Eyelet hole punch
- 2 silver eyelets, ¼ inch (6 mm) each
- 10 inches (25.4 cm) of silver ribbon, ⅝ inch (1.6 cm) wide
- 10 inches (25.4 cm) of gold ribbon, ⅝ inch (1.6 cm) wide
- 4 squares of gold cardstock, each 2 inches (5 cm) square
- 2 gold metal charms
- 2 silver metal charms
- 16 inches (40.6 cm) of very thin gold cord

NOTE

This design works very well for a formal, printed invitation. Just use the invitation card itself to cover up the ribbon ends inside, omitting the gold corners.

■ STEP BY STEP

1 Measure 3 inches (7.6 cm) in from each 6-inch (15.2 cm) side of your cardstock. Score and fold the cardstock in toward the center to create a gatefold.

2 Arrange the 3-inch (7.6 cm) squares of metallic paper in a checkerboard pattern, aligning the edges with each center line. Glue each square down and roll with a brayer. Use a mat knife and metal ruler to trim off any excess paper that hangs over the edges.

3 Punch out four 1-inch (2.5 cm) circles from the silver cardstock. Using an eyelet hole punch, punch out a ¼-inch (6 mm) hole in the center of each silver circle. Measure halfway down each gatefold and then ¾ inch (1.9 cm) in from the center flaps, and mark with a dot.

Punch a ¼-inch (6 mm) hole at each marking. Thread the eyelet so it goes through the silver circle, the hole in the card, and the second silver circle. Set the eyelet. Repeat on the other flap of the gatefold.

4 Cut the metallic ribbon into four 5-inch (12.7 cm) pieces. Using the project photo as a guide for placement, wrap a ribbon around each of the four card corners. Use double-sided tape to secure one end of each ribbon inside the card flap. Tape the other ribbon ends to the back of the card.

5 To hide the ribbon ends, cover the back and inside flap corners of the card with pieces of metallic cardstock.

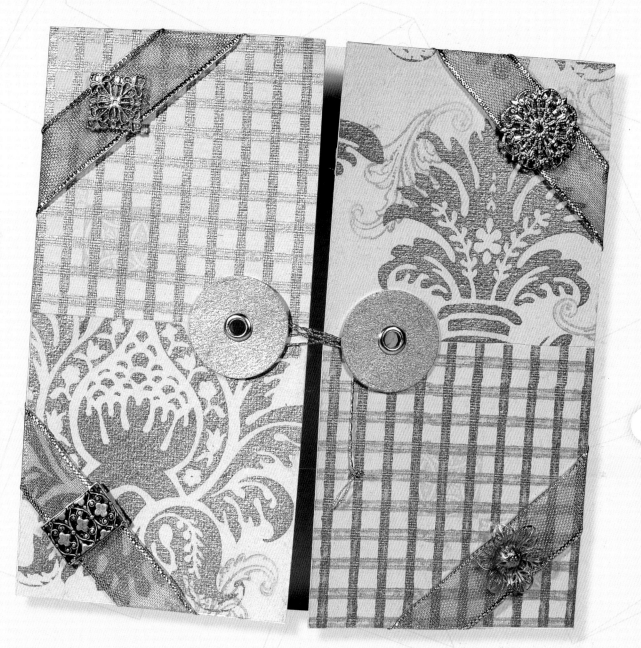

6 Center a metal charm on each ribbon, and attach it using industrial glue. Press firmly to secure.

7 Tie one end of the gold cord around the eyelet, underneath the silver circle. Wind the remainder of the cord around the other eyelet to create a closure.

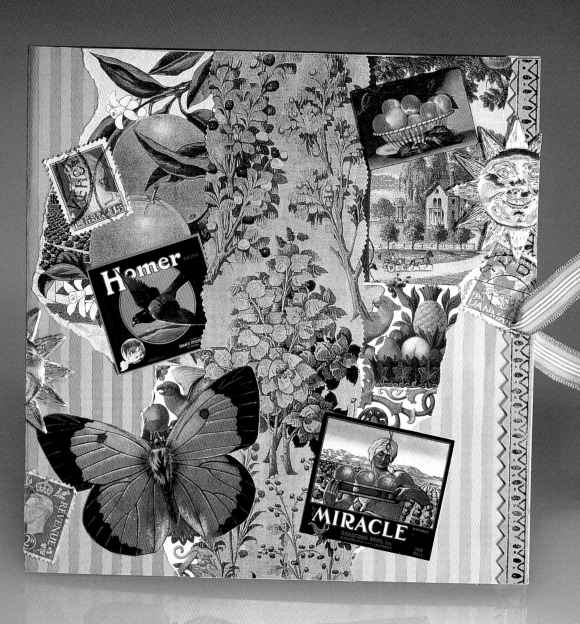

Orange Grove

Vintage fruit crate art is the inspiration for this juicy, fresh-picked card. Brightly colored fruits and vegetables are a perfect starting point for a bold color-themed card.

MATERIALS

- 6 x 12-inch (15.2 x 30.5 cm) piece of orange cardstock
- Orange watercolor paint & paintbrush
- 2½ x 6-inch (6.4 x 15.2 cm) piece of orange patterned paper
- 3 pieces of orange-themed ephemera
- 3 orange crate labels or small pictures
- 3 orange-colored postage stamps
- Large orange butterfly image
- 6-inch (15.2 cm) strip of decorative gold metallic trim, ½ inch (1.3 cm) wide
- Gold foil sun (or other gold metal sticker)
- 18 inches (45.7 cm) of orange striped ribbon, ⅜ inch (9.5 mm) wide

NOTE

I used a craft knife and metal ruler to cut my foil sun in two sections, gluing one to the card's right-hand side and one to the left.

▪ STEP BY STEP

1 Fold the orange cardstock to make a 6 x 6 inch (15.2 x 15.2 cm) card.

2 Use a pencil to mark ⅛-inch (3 mm) wide vertical stripes across the entire face of the card.

3 To create a two-toned effect, paint alternating stripes with orange watercolor paint. Allow the paint to dry thoroughly.

4 Trim each 6-inch (15.2 cm) edge of the patterned paper with large scalloped scissors.

5 Lay a 6-inch (15.2 cm) piece of double-sided tape down the vertical center of the card.

Stick the patterned paper onto the centerline, leaving both scalloped edges loose.

6 Tear or trim around the pieces of ephemera. Arrange your ephemera, butterfly image, crate labels, and stamps so they flow down each scalloped side of the patterned paper. Tuck some underneath the scalloped edges and let others flow on top. Glue the pieces down.

7 Adhere the metallic trim to the right-hand edge and glue down the foil sun.

8 Using the project photo as a guide, punch a hole that goes through both the front and back pieces, thread a ribbon through the holes and tie a bow. Trim the ribbon ends.

COLORS

Focal Points

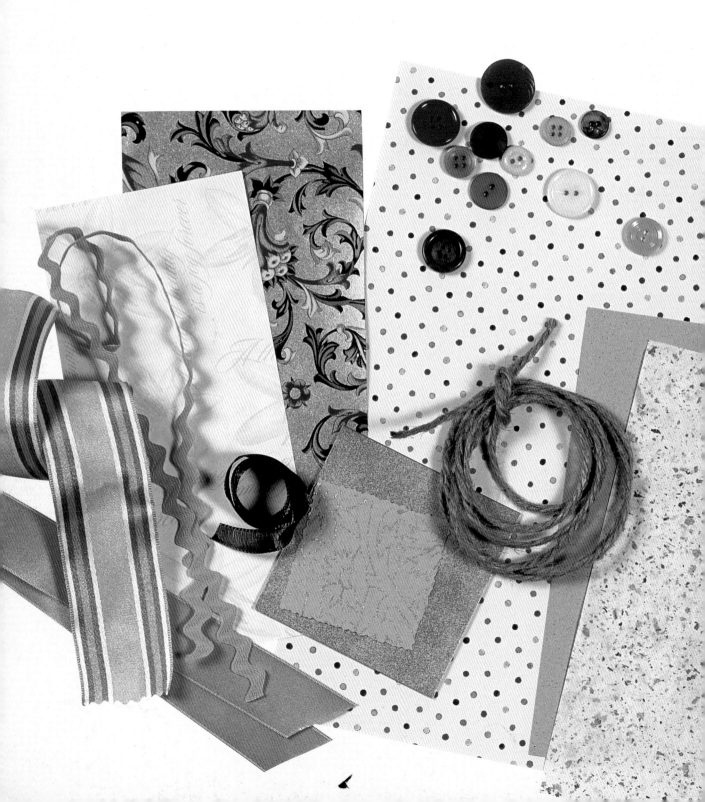

The focal point of a greeting card can be as small as a postage stamp or as large as a postcard. It is what your eye is drawn to first. Placement is the key to creating a focal point, but that doesn't mean the focal element must be positioned perfectly straight or centered on the card. Try moving pieces around to discover what you look at first.

Surrounding elements, a cutout window, contrasting colors, or opposing pattern and scale can create a focal point just as effectively as a powerful image. A smaller element can actually triumph over a larger one in drawing your eye—experiment and see! In *Golden Pears* (page 38), the window makes the small harvest painting the focal point, even though the pear image is larger and its colors more intense. Note that the same image is used on *Harvest Party* (page 88), but in that card layout, the harvest painting is not the focal point.

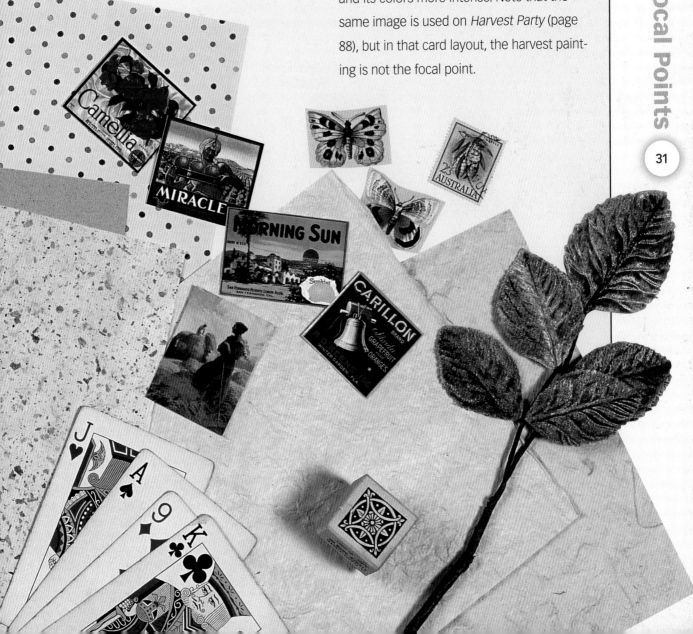

Vanilla Bean

With natural-colored papers and a raffia tie, this card is reminiscent of a treasured cargo package from an exotic country. Botanical illustrations, with their delicate details, can work well for a central image, as accents, or even as a background.

MATERIALS

- 7 x 10-inch (17.8 x 25.4 cm) piece of kraft-colored cardstock
- 5 x 7-inch (12.7 x 17.8 cm) piece of rough oatmeal paper
- 4 x 6-inch (10.2 x 15.2 cm) piece of speckled rice paper
- Botanical picture (to be used as central image)
- Piece of solid tobacco-colored fiber paper, large enough to back main picture image
- 4 adhesive foam dots
- 7 brown-toned postage stamps
- 5 additional small botanical-type images
- 2 postal mark rubber stamps
- Sepia-colored ink pad
- ⅛-inch (3 mm) hole punch
- 3 feet (91.4 cm) of brown package twine

■ STEP BY STEP

1 Fold the kraft-colored cardstock to make a 5 x 7-inch (12.7 x 17.8 cm) card.

2 Tear ¼ inch (6 mm) off each edge of the oatmeal paper, glue down in the center of the card face, and roll it with a brayer. Repeat the same process with the speckled paper, except glue it down on top of the oatmeal paper.

3 Glue your largest botanical image onto the piece of solid tobacco-colored backing paper, and tear off each edge around the picture so about 1/8 inch (3 mm) is showing as a border.

4 Press an adhesive foam dot on the back of all four corners of the botanical assemblage and attach it to the center of the card.

5 Arrange the smaller pictures and stamps around the central image, tucking some of them underneath the open sides. Glue them down.

6 Ink your postage rubber stamps with sepia ink, and stamp just a few impressions in the open spaces of your card, overlapping some of the stamps and pictures.

7 For an antiqued look, swipe all four edges of the card front in the sepia ink pad.

8 Mark the center point of all four sides of your card face. Use the ⅛-inch (3 mm) hole punch

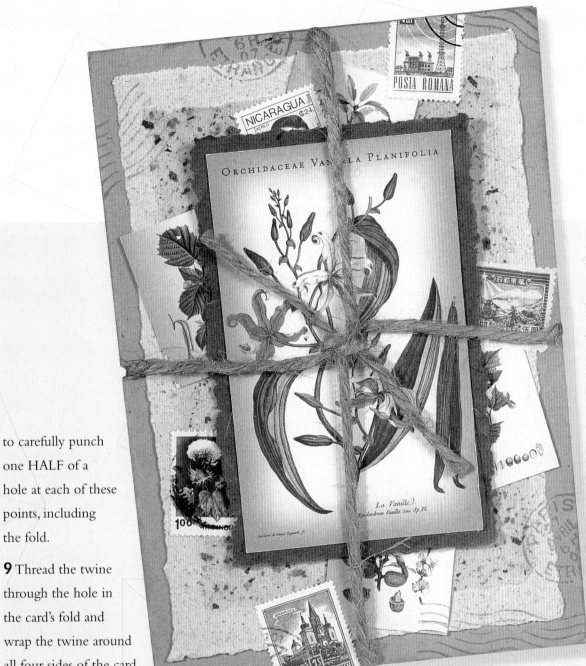

to carefully punch one HALF of a hole at each of these points, including the fold.

9 Thread the twine through the hole in the card's fold and wrap the twine around all four sides of the card as if you were tying a package. Tie the twine at the center front in a double knot and trim the ends fairly short, creating the look of a cargo package.

10 Use any remaining stamps and images on the inside corners of the card, accenting them with rubber stamps.

Organg Grinder

Buttons, rickrack, and polka dots add lighthearted fun to this delightful focal point. Battered children's textbooks and readers can be a rich source of charming artwork for collage and are widely available at thrift stores and flea markets.

FOCAL POINTS

MATERIALS

- 7 x 10-inch (17.8 x 25.4 cm) piece of yellow-gold cardstock
- 5 x 7-inch (12.7 x 17.8 cm) piece of polka dot patterned paper
- Old children's book colored illustration, approximately 3¼ inches (8.3 cm) square
- Large enough piece of white cardstock to back the illustration
- 15 inches (38.1 cm) of bright yellow-gold rickrack
- 7 brightly colored buttons of different sizes
- 20 inches (50.8 cm) of bright yellow-gold embroidery floss
- 1 x 7-inch (2.5 x 17.8 cm) strip of polka dot patterned paper

■ STEP BY STEP

1 Fold the gold cardstock in half to make a 5 x 7-inch (12.7 x 17.8 cm) card.

2 Use regular pinking shears to trim ⅛ inch (3 mm) off of each side of the 5 x 7-inch (12.7 x 17.8 cm) polka dot paper. Glue the paper to the center of the card front, and roll with a brayer.

3 Glue the illustration onto the piece of white cardstock, and roll with the brayer.

4 Apply thin strips of double-sided tape to the perimeter of the back of the illustration.

5 Peel off the tape backing. Starting at the upper left corner, press the rickrack onto the tape, folding it over at each corner.

6 Center the illustration 1 inch (2.5 cm) down from the top of the card, and attach using generous pieces of double-sided tape.

7 Use industrial glue to attach the largest button to the upper left-hand corner of the illustration (snipping off the shank if necessary). Let the glue dry thoroughly.

8 Cut a 10-inch (25.4 cm) piece of embroidery floss, and string the buttons onto it.

9 Mark a point on the spine 2½ inches (6.4 cm) up from the bottom, and poke a hole with an embroidery needle. Thread one end of the floss through this hole and knot it.

10 Tape the other end of the floss to the inside left-hand edge of the card, 2½ inches (6.4 cm) up from the bottom, letting the button string form a swag. Either let the buttons hang loose, or tape each one down with double-sided tape.

11 Cut the remaining floss in half, and knot both pieces around the button in the upper left-hand corner.

12 Cut the 1 x 7-inch (2.5 x 17.8 cm) strip of polka dot paper in half lengthwise with pinking shears. Glue one strip to each 7-inch (17.8 cm) side on the inside of the card, covering up the taped floss end.

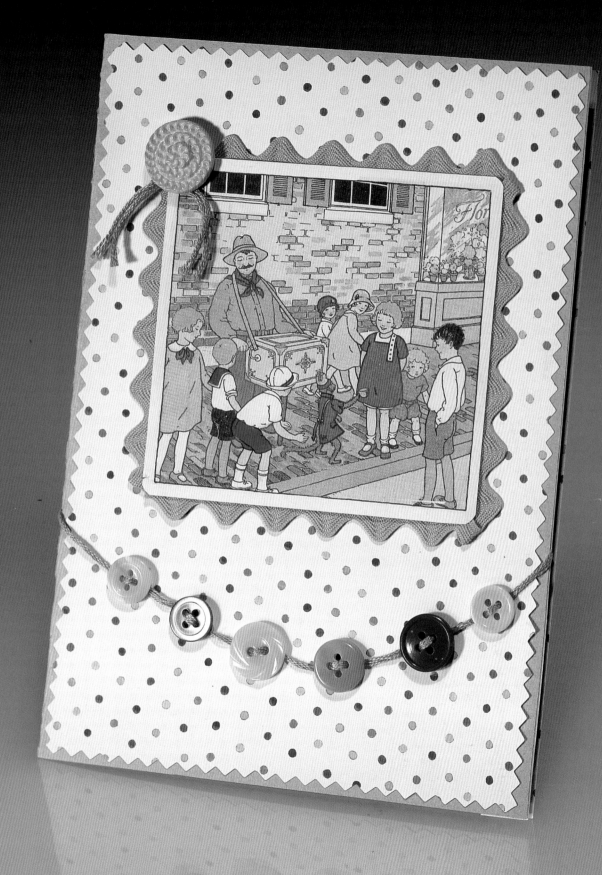

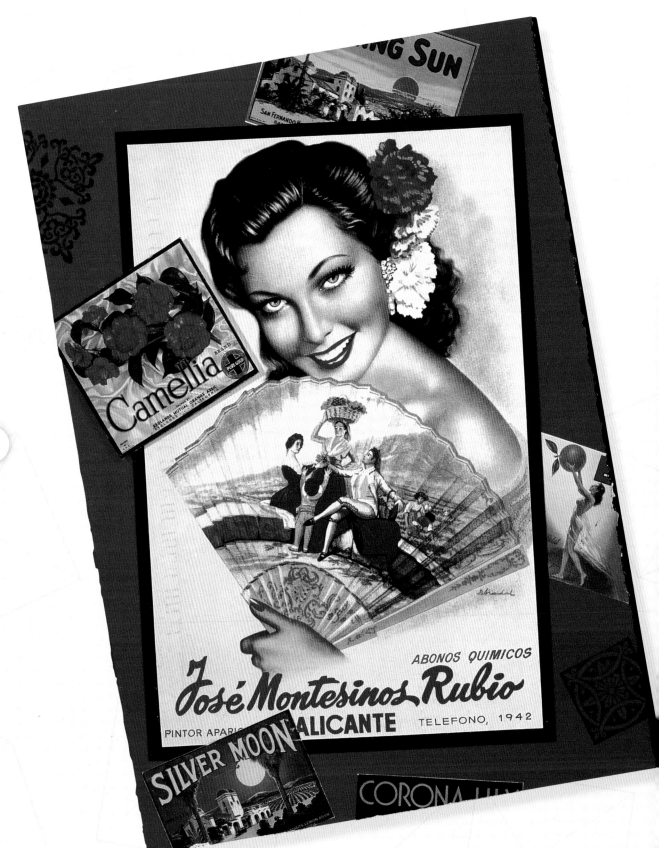

Señorita

Greetings from my well-traveled sister inspired this dramatic design. Seductive and splashy, this card uses an interesting mix of colorful fruit crate labels and a postcard of a Spanish señorita for a strong central statement.

MATERIALS

- 7 x 10-inch (17.8 x 25.4 cm) piece of red cardstock
- ½ x 7-inch (1.3 x 17.8 cm) strip of black cardstock
- Colorful Spanish postcard
- 4 x 6-inch (10.2 x 15.2 cm) piece of black cardstock
- 5 fruit crate or floral labels
- Scrap of black cardstock (to mount one label)
- 4 adhesive foam dots
- 2 decorative square "tile" rubber stamps
- Embossing stamp pad, black embossing powder, and heat gun

STEP BY STEP

1 Fold the red cardstock to make a 5 x 7-inch (12.7 x 17.8 cm) card.

2 Using deckled scissors, trim $\frac{1}{16}$ inch (1.6 mm) off the right-hand edge of the card and $\frac{1}{16}$ inch (1.6 mm) off one long edge of the 7-inch (17.8 cm) black strip.

3 Glue the strip down on the inside right-hand edge so that the deckle-trimmed portion lies on the left. A thin black edging should now be visible when the card is closed.

4 Glue the postcard onto the 4 x 6-inch (10.2 x 15.2 cm) piece of black cardstock, and trim so there is a ⅛-inch (3 mm) border visible around the postcard.

5 Mount your favorite fruit label on a slightly large piece of scrap black cardstock, and trim to create a $\frac{1}{16}$ inch (1.6 mm) border around all four sides.

6 Angle the unmounted labels over and under the postcard; stick down the labels and then glue the postcard at an angle on top.

7 Attach a foam dot to each back corner of the mounted fruit label, and stick it on top of the postcard to create a layered effect.

8 Use the embossing pad to stamp a tile rubber stamp image in an open space on the card front, sprinkle with black embossing powder, and then set it with a heat gun. Repeat with each additional stamped image.

9 Tap the deckled edge of the card front on the embossing pad, then dip it into the black embossing powder. Gently tap off any excess powder, and heat the edge with the gun to make a glossy border.

Golden Pears

This juicy card features a gorgeous lithograph of pears and extravagant ribbon trim, but it is the wistful woman in the field who provides a pensive focal point. As shown with this card, hand-cut windows can be used with great effect to emphasize the unexpected.

MATERIALS

- 8½ x 10 inches (21.6 x 25.4 cm) sheet of pale green cardstock
- 5 x 8½-inch (12.7 x 21.6 cm) piece of yellow patterned paper
- 4 x 8½-inch (10.2 x 21.6 cm) piece of script patterned paper
- 4 x 8½-inch (10.2 x 21.6 cm) piece of gold metallic paper
- 6 green-toned postage stamps
- 3 x 5-inch (7.6 x 12.7 cm) piece of fruit artwork (other subjects are fine too)
- Portrait or landscape artwork, about 1½ x 2 inches (3.8 x 5 cm)
- 2½ x 3-inch (6.4 x 7.6 cm) piece of spring-green patterned paper
- 2 x 3-inch (5 x 7.6 cm) piece of gold metallic mat board
- Butterfly picture or sticker
- ¼-inch (6mm) hole punch
- 10 inches (25.4 cm) of wired yellow and green satin ribbon, 1½ inches (3.8 cm) wide

NOTE

Learning to create paper-framed windows is a little tricky at first but worth it. Once you get the hang of it, windows can be done in many different sizes, always creating a nifty diamond shape on the inside of the card. See page 118 for inside treatment ideas.

STEP BY STEP

1 Fold the pale green cardstock to make a 5 x 8½-inch (12.7 x 21.6 cm) card.

2 Center the yellow paper on the card, glue down, and roll with a brayer.

3 Tear ⅛ inch (3 mm) off of each long side of the script paper.

4 Glue the torn script paper on top of the gold paper, lining up the top and bottom edges. Roll both sheets with the brayer.

5 Cover the back of the gold paper with glue, except for ½ inch (1.3 cm) along each long edge (allowing you to slip the green stamps in underneath). Adhere the gold paper down on top of the yellow paper, aligning the top and bottom edges.

6 Arrange the postage stamps under the gold paper edges as shown, and glue them down.

7 Trim the fruit artwork so it measures 5 inches (12.7 cm) wide, and glue it across the bottom of the card.

8 Measure the size of your small landscape or portrait, and add ⅛ inch (3 mm) in each direction. This will be the size of your window cutout. Find the center at the top of the card, and measure down 2½ inches (6.4 cm). Rule out the measurement of your window below the 2½-inch (6.4 cm) guide, and use the mat knife to carefully cut out the window, cutting through all the paper layers on the card front.

9 Trim all four edges of the spring-green paper with deckle-edged scissors. Open the card

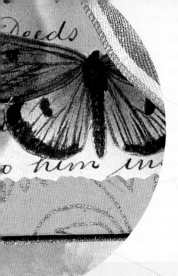

and lay it down so the front and back covers face you. Spread glue over the entire back of the green paper and press it down, centered, over the cutout window.

10 On the inside of the card, use the mat knife to cut a neat "X" through the green paper that is covering the window. Peel back each triangle of the "X" and stick it down to the inside of the card, using more glue if necessary. It should now form a diamond shape.

11 Glue the small piece of landscape or portrait art onto the gold mat board. Trim a ⅛-inch (3 mm) border all around the art with deckle-edged scissors. Center the art behind the window opening, and stick the mat board piece down with double-sided tape.

12 Stick or glue a butterfly centered directly over the window. Use the mat knife to trim off any overhanging papers from the top and bottom edges.

13 Measure down ½ inch (1.3 cm) from the top of the card and 2¼ inches (5.7 cm) from each side. Mark with a pencil dot, and punch a ¼-inch (6 mm) hole directly over each dot. Thread the ribbon through the holes from front to back, and then back through to the front, forming a loop. Plump up the knot, and trim the ends with pinking shears.

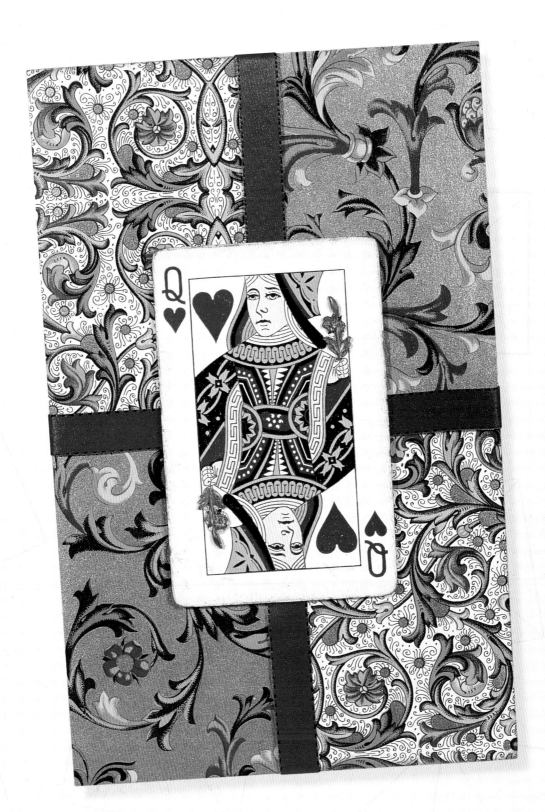

Florentine Queen

Celebrate your "Queen (or King) for a Day" with a card fit for royalty. Transformed with luxurious Florentine papers and a rich ribbon, an old playing card becomes an elegant centerpiece.

MATERIALS

- 7 x 9-inch (17.8 x 22.9 cm) piece of deep red cardstock
- 4 pieces of different Florentine-patterned papers, each 3½ x 2¼ inches (8.9 x 5.7 cm)
- Gold stamp pad
- 2 feet of dark red satin ribbon, ⅜ inch (9.5 mm) wide
- Queen of hearts playing card
- 2 small gold floral charms

TIP

A large embroidery needle comes in handy to gently remove any excess industrial glue that might squish out beyond the edges of intricate metal charms.

STEP BY STEP

1 Fold the cardstock to make a 4½ x 7-inch (11.4 x 17.8 cm) card.

2 Glue the Florentine papers onto the face of the card, aligning the outside edges for the best fit. Roll thoroughly with a brayer.

3 Tap all four sides of your card in the gold stamp pad to create gold edging.

4 Measure down 3¼ inches (8.3 cm) from the top of the card spine. Cut a ½-inch (1.3 cm) slit just behind the fold of the spine.

5 Cut the ribbon into two pieces, one measuring 9 inches (22.9 cm) and the other 14 inches (35.6 cm). Thread the shorter piece through the slot so that both ends are in the center front of the card, covering up the horizontal seam of the

Florentine papers. Tack down the ends with double-sided tape.

6 Wrap the longer piece of ribbon around the vertical centerline of the card so that both ends are in the center front. Tack down both ends with double-sided tape.

7 Tap all four sides of the playing card in the gold stamp pad to give it a gold edging.

8 Place a foam adhesive square in each corner on the backside of the playing card.

9 Firmly press the Queen of Hearts card down in the very center of the card, covering up all the ribbon ends.

10 Spread a tiny bit of industrial glue on the backs of both small gold floral charms, and place one in each of the Queen's hands.

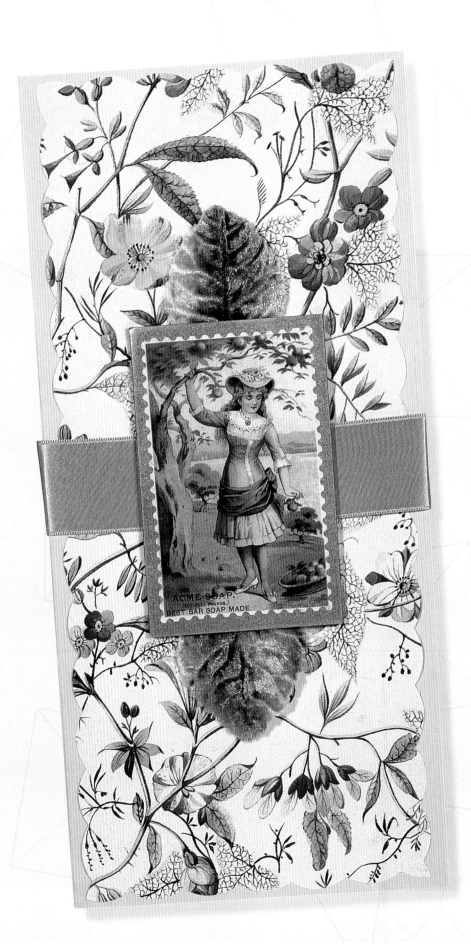

Acme Soap Girl

Product packaging can be a fabulous source for collage—food and cosmetics are my favorites. Here a vintage wrapper for Acme Soap makes a pretty central image. Note how the two versions pick up different colors in the same picture.

MATERIALS

- 8 x 8½-inch (20.3 x 21.6 cm) piece of pale green cardstock
- 4 x 8½-inch (10.2 x 21.6 cm) piece of decorative floral paper
- 8-inch (20.3 cm) piece of pale green satin ribbon, 1 inch (2.5 cm) wide
- Victorian advertising image, no larger than 2 x 3 inches (5 x 7.6 cm)
- Piece of gold mat board (to back the advertising image)
- Gold ink pad
- Two soft green velvet leaves

NOTE

The variation uses different sized cardstock and picks up entirely different hues in the picture, creating a varied look while using exactly the same techniques.

■ STEP BY STEP

1 Fold the cardstock to make a vertical 4 x 8½-inch (10.2 x 21.6 cm) card.

2 Use scallop-edge scissors to trim ⅛ inch (3 mm) off all four sides of the floral paper. Glue the floral paper down in the center of the card front, and roll thoroughly with a brayer.

3 Mark the halfway point down along the spine. Measure and mark ½ inch (1.3 cm) both above and below your center point, and use a ruler and mat knife to cut a 1-inch (2.5 cm) slot just behind the card's fold.

4 Thread the ribbon through the slot and bring both ends to the front of the card, securing them at the center with double-sided tape.

5 Trim the edges of your Victorian image with stamp-edged scissors.

6 Glue the image to a piece of gold mat board that is at least ⅛ inch (3 mm) larger on all four sides than the image. Trim the board with a mat knife and ruler so that there is a ⅛-inch (3 mm) border all around the picture.

7 Tap the edges of the gold mat board in the gold ink pad to give it a finished look.

8 Tape the two velvet leaves behind the Victorian picture using double-sided tape.

9 Use double-sided tape to attach the Victorian image and leaf assembly to the very center of the card, covering up the two cut ribbon ends.

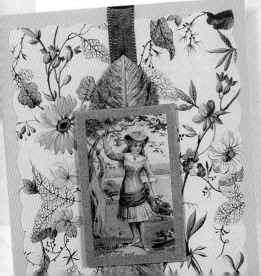

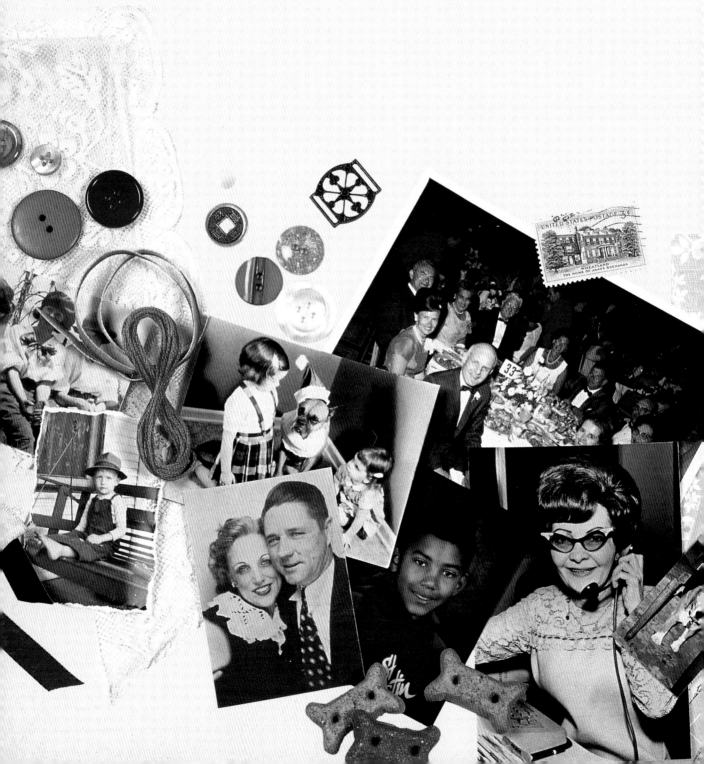

Photographs add a sense of immediacy to collage cards. Whether historical portraits, rural landscapes, or the family dog, they can pull you right into the picture.

Size and condition or whether the photos are color or black and white doesn't matter. Tiny snapshots can be used to great effect when framed by a window like the one seen in *Patchwork Window* (page 18), and a blurry tattered landscape can create a moody background as proven with *Our House* on page 58. Damaged photos can either be cropped or damaged even further to create a different look. I literally burned the edges of the *Empress Dowager* photo (page 52) to give it a more battered, historical quality. While many collagists might tend to use photos of their own family members, don't disregard the old photo bin at your nearby thrift store. My *Birdhouse Sisters* (page 48) are unknowns—castoffs from a local pawnshop—yet their sad faces make a poignant focal point.

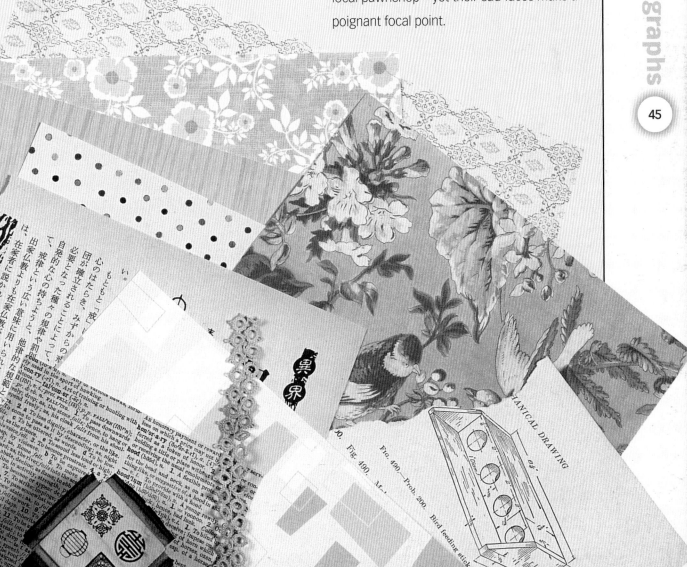

Beehive Girls

Not a sprayed hair out of place, these gals and their beaus are all dressed up for the big day (Mother's Day 1971). Photos from the 1950s, '60s, and '70s are a great fit with retro and pop-art-themed papers.

MATERIALS

- 7 x 10-inch (17.8 x 25.4 cm) piece of pink cardstock
- 4¾ x 6¾-inch (12.1 x 17.2 cm) piece of "mod" patterned paper
- 4 x 6½-inch (10.2 x 16.5 cm) piece of tracing paper
- 3½ x 5-inch (8.9 x 12.7 cm) "retro" photo
- Scrap piece of the same "mod" paper
- Scrap piece of cardstock, about the same size

■ STEP BY STEP

1 Fold the pink cardstock to make a 7 x 5-inch (17.8 x 12.7 cm) card.

2 Glue the patterned paper on the center of the card front, and roll with a brayer.

3 Lay the tracing paper over your photo and rule out a slanted rectangle that frames the people in your picture, making sure that the photo itself is straight.

4 Cut out the slanted rectangle, and trace it on the center of the patterned paper.

5 Use a mat knife and ruler to cut out the traced rectangle from the face of the card.

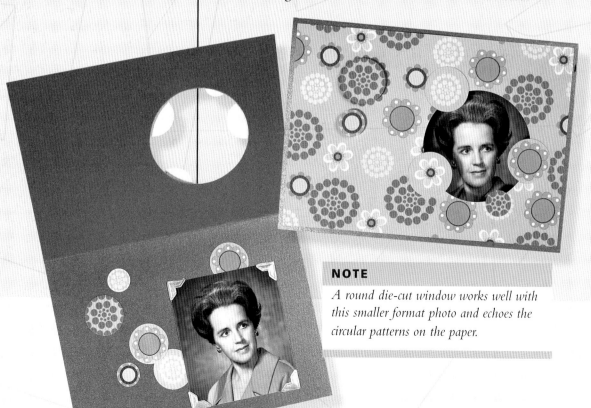

NOTE

A round die-cut window works well with this smaller format photo and echoes the circular patterns on the paper.

6 Place the photo behind the window, and glue it in place.

7 Glue your scrap piece of patterned paper onto a similar-sized piece of cardstock, and roll it with the brayer.

8 Use a mat knife or scissors to cut out three shapes from the patterned paper scrap piece that was glued onto the cardstock.

9 Arrange the three shapes around the edge of your rectangular window (making sure none of the people are covered up), and tape each one down on the card face edge with small pieces of double-sided tape.

Birdhouse Sisters

The haunting faces in this photograph of two sisters make a wonderful focal point for a collage comprised of schoolbook memorabilia, dictionary definitions, and a bird feather they may have picked up on their walk to school.

MATERIALS

- 7 x 10-inch (17.8 x 25.4 cm) piece of floral-patterned cardstock
- Sheet of "dictionary" patterned paper
- Postage stamp
- Pages from old children's textbooks
- Feather
- Black and white photo (not too large)
- 4 adhesive foam dots
- 9-inch (22.9 cm) length of ecru lace

■ STEP BY STEP

1 Fold the patterned cardstock in half.

2 Tear the edges of the dictionary paper, and glue it down along the left edge and lower right corner.

3 Refer to the photo for placement, and use craft glue to attach the postage stamp and pieces of the textbook pages.

4 Place industrial glue on the spine of the feather, and press down.

5 Affix the photo with four foam dots.

6 Wrap the lace around the right edge of the card front, and adhere it to the inside front with double-sided tape.

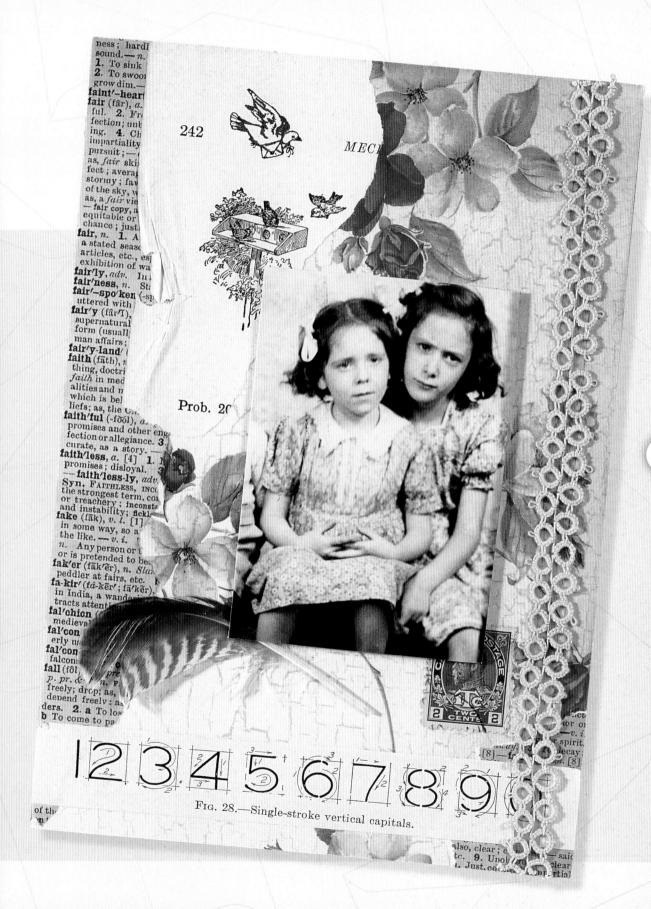

FIG. 28.—Single-stroke vertical capitals.

Birthday Flags

A face full of frosting and a candle to blow—everyone loves to take photographs of a child's birthday party. That special picture is celebrated here with colorful stripes and festive pennants.

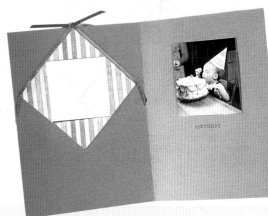

MATERIALS

- 7 x 10-inch (17.8 x 25.4 cm) piece of periwinkle cardstock
- Birthday photo, a maximum size of 2⅛ inches (5.4 cm) square
- 5 x 7-inch (12.7 x 17.8 cm) piece of brightly colored striped paper
- Flag template (page 124)
- 4 scraps of colored cardstock (to match stripes), each measuring 1½ x 5 inches (3.8 x 12.7 cm)
- 2 feet (61 cm) of periwinkle satin ribbon, ⅛ inch (3 mm) wide
- Embroidery needle
- Large brightly colored button
- ⅜ x 4-inch (9.5 mm x 10.2 cm) scrap of periwinkle cardstock
- Number and alphabet rubber stamps
- Colored ink pads

STEP BY STEP

1 Fold the periwinkle cardstock to make a 5 x 7-inch (12.7 x 17.8 cm) card.

2 Measure the size of the cropped image in the photo that you wish to feature. Measure down 1¼ inches (3.2 cm) from the top center point of your card face, and draw your picture measurement. This will be the window frame for your card.

3 Use a mat knife and ruler to carefully cut out this window from the face of your card.

4 Use pinking shears to trim ¼ inch (6 mm) off all four sides of the striped paper.

5 Center and glue the piece of striped paper to the face of your card. Use a ruler and pencil to draw an "X" across the window opening on the inside of the card.

6 Cut along the "X" with the ruler and mat knife. Peel back the triangles, gluing each one down (apply more glue if needed). The striped paper should now form a diamond shape.

7 Use the template on page 124 to trace four flags of different colors onto the colored cardstock scraps. Cut them out using a ruler and a mat knife.

8 Apply thin strips of double-stick tape to the top of each flag, and tape them in a row onto the center of the ribbon.

9 Measure down 3½ inches (8.9 cm) along the spine of the card, and cut a small slit for the ribbon to go through. Thread one end of the ribbon through the slit.

10 Use the needle to thread the button onto the other end of the ribbon, then punch a hole with the needle through the cardstock about ⅛ inch (3 mm) in from the center edge.

11 Pull the two ends of the ribbon up to the top of the card. Tie them in a bow and anchor the bow to the top edge of the

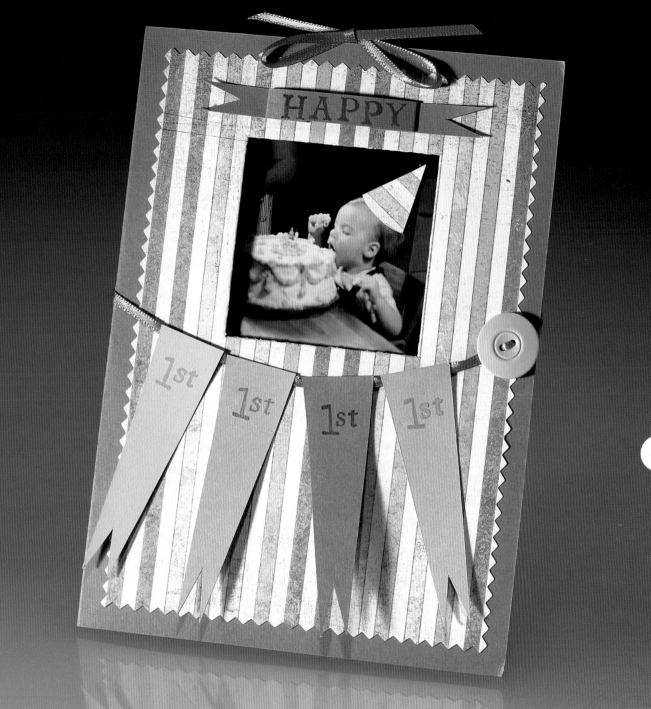

card with a small piece of double-sided tape.

12 Form the banner by cutting a ⅜ x 4-inch (9.5 mm x 10.2 cm) strip of cardstock. Measure in 1 inch (2.5 cm) from each end, and make a ¼-inch (6 mm) fold. Cut each end in a "V," and glue down above the photo.

13 Stamp the number of the birthday on each flag and the name or a birthday greeting on the banner above.

Empress Dowager

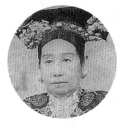

The burned edges give this photograph a patina of history. Somber yet dramatic, this grand dame in her extravagant robes is accented by a vivid red and black ribbon and a delicately carved "ivory" charm.

MATERIALS

- 7¼ x 10-inch (18.4 x 25.4 cm) piece of manila cardstock
- 2 pages of a vintage Asian calligraphy text
- Small paintbrush
- Candle and matches
- 4 x 6-inch (10.2 x 15.2 cm) photo or postcard
- Asian character rubber stamp
- Black ink pad
- 20 inches (50.8 cm) of deep red satin ribbon, ⅜ inch (9.5 mm) wide
- Large "ivory" bead or embellishment

STEP BY STEP

1 Fold the manila cardstock to make a 5 x 7¼-inch (12.7 x 18.4 cm) card.

2 Tear the vintage Asian text pages into pieces about 1½ inches (3.8 cm) wide. You will need about 40 pieces.

3 Mix a small amount of water with craft glue. Using a small brush, paint the thinned glue onto a piece of Asian text, and glue it down to an edge of the card. Repeat with the other pieces until you have created a 1-inch (2.5 cm) "frame" around the entire face of the card. When all the pieces are in place, coat with another thin layer of glue and let dry.

4 After the text pieces are dry, trim off any excess paper from the card edges.

5 Light the candle and place it in a holder. Burn all four edges of your photograph, blowing the burning paper out frequently so it doesn't advance too far into the photograph (or create a fire hazard!).

6 Glue the photograph in the center of the card over the calligraphy frame.

PHOTOGRAPHS

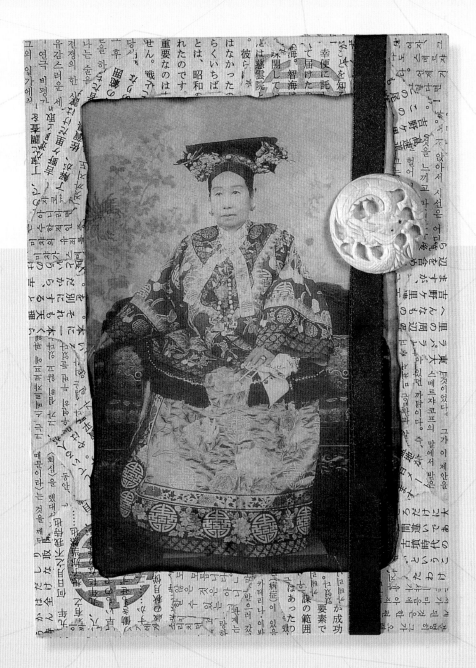

7 Ink your rubber stamp with the black ink pad, and stamp one or two impressions on the face of the card. Do this sparingly so it doesn't look too cluttered.

8 Wrap the ribbon around the card from bottom to top, about 1 inch (2.5 cm) in from the right-hand edge. Tape the lower end down about 2 inches (5 cm) from the card's upper edge, and then tape the top end over the first. Trim the ribbon at an angle, leaving a nice long end.

9 Use industrial glue to attach the ivory piece on top of the ribbon at the point where it was taped down.

MATERIALS

- 10½ x 7¼-inch (26.7 x 18.4 cm) ivory cardstock
- 17 inches (43.2 cm) of wide scalloped lace
- 30 inches (76.2 cm) of wired ivory-colored satin ribbon, 1 inch (2.5 cm) wide
- ¼-inch (6 mm) hole punch
- 5¼ x 7¼-inch (13.3 x 18.4 cm) piece of ivory or cream cardstock
- 2 x 3-inch (5 x 7.6 cm) wedding photo
- 2¼ x 3¼-inch (5.7 x 8.3 cm) piece of ivory cardstock
- 3 x 5-inch (7.6 x 12.7 cm) ivory scalloped oval
- Ivory or abalone shell leaf ornament

NOTE

Die-cut scalloped ovals like the one pictured here are available in many paper stores. If you can't find one, create a substitute by cutting a 3 x 5-inch (7.6 x 12.7 cm) rectangle out of ivory cardstock using scalloped scissors.

Ivory Gown

Whether it's their first or their 50th, using a wedding photograph for an anniversary card truly turns it into a cherished keepsake. The wide band of lace and fancy ribbon echo bridal gown finery and create a beautiful backdrop for this portrait.

■ STEP BY STEP

1 Fold the larger piece of ivory cardstock to make a 5¼ x 7¼-inch (13.3 x 18.4 cm) card.

2 Lightly rule a line down the vertical center of the card front.

3 Place an 8¼-inch (21 cm) strip of ½-inch-wide (1.3 cm) double-sided tape down the center of the card front. It should extend beyond the edges of the card. Leave the backing in place.

4 Cut the lace into two 8½-inch (21.6 cm) pieces. Carefully peel back the backing paper from the tape strip and apply one strip of lace along the centerline. The lace should overhang the upper and lower edge of the card by at least ½ inch (1.3 cm). Repeat on the opposite side with the other lace piece.

5 Open the card and wrap the lace edges around to the inside. Work from now on with the card open so the tape behind the

lace doesn't stick to the card surface.

6 Apply a second strip of double-sided tape exactly over the first one, and peel off the backing paper.

7 Cut an 8½-inch (21.6 cm) length of ribbon, and press it down on the tape strip. Fold the ribbon edges onto the inside of the card, directly over the lace.

8 Measure 1¼ inches (3.2 cm) down from the top on your centerline. Punch two ¼-inch (6 mm) holes about ½ inch (1.3 cm) apart from each other right through the ribbon, lace, and paper of the card face.

9 Thread your remaining length of ribbon through the two holes, from the inside to the front, and tie in a generous bow. Cut deep "V" shapes in the tails of the bow, and plump up the knot.

10 Use scalloped-edge scissors to trim ¼ inch (6 mm) off of each side of the 5¼ x 7¼-inch (13.3 x 18.4 cm) piece of ivory cardstock.

11 On the inside of the card, use double-sided tape to secure the scalloped piece of ivory cardstock to the center of the left-hand side, covering up all the lace and ribbon ends.

12 Glue the wedding photo to the smallest piece of ivory cardstock, and trim the edges so a ⅟₁₆-inch (1.6 mm) border shows around all four sides of the photo.

13 Glue the photo onto the scalloped oval. Center the oval below the bow, and attach it using adhesive foam dots.

14 Apply the ivory or abalone decoration with a generous dab of industrial glue, directly under the knot of the bow, and let it dry thoroughly.

Dog Biscuits

Beagles love their biscuits, and this little guy is no exception! Concentric frames form a window on a favorite pet, while real biscuits make a cute embellishment—and can also serve as removable treats.

MATERIALS

- 6 x 12-inch (15.2 x 30.5 cm) piece of periwinkle cardstock
- 5¾-inch (14.6 cm) square of orange patterned paper
- 5-inch (12.7 cm) square of pale periwinkle patterned paper
- 4¼-inch (10.8 cm) square of a multi-colored patterned paper
- 12 inches (30.5 cm) of gold rickrack
- 4 small dog biscuits (real or die-cut wood)
- Embroidery needle
- 2 feet (61 cm) each of gold and periwinkle embroidery floss
- Pet photo, 3 inches (7.6 cm) square

NOTE

See page 123 for inside treatment ideas.

■ STEP BY STEP

1 Fold the periwinkle cardstock in half to make a 6-inch-square (15.2 cm) card.

2 Use pinking shears to trim ⅛ inch (3 mm) off each side of both the orange and the multi-colored paper squares.

3 Glue down the orange paper, then the periwinkle paper, and finally the multi-colored paper, turning them all askew, as seen in the project photo. Roll all the paper layers with a brayer.

4 With a pencil, lightly rule out a 2½-inch (6.4 cm) square in the very center of the card, and cut out through all the paper layers, using a metal ruler and mat knife.

5 Open the card and place four thin strips of double-sided tape around the perimeter of the window.

6 Starting in a corner, press rickrack onto the tape, folding it over at each corner.

7 Place the four biscuits on the card face, one in each corner, each tilted slightly. Draw a pencil dot on either side of the center portion of each biscuit.

8 Using an embroidery needle, poke a hole at each pencil dot through all the paper layers. Thread the embroidery floss through the holes, and tie down each biscuit.

9 Place the pet photo behind the window, making sure it's straight, and tape down with double-sided tape.

PHOTOGRAPHS

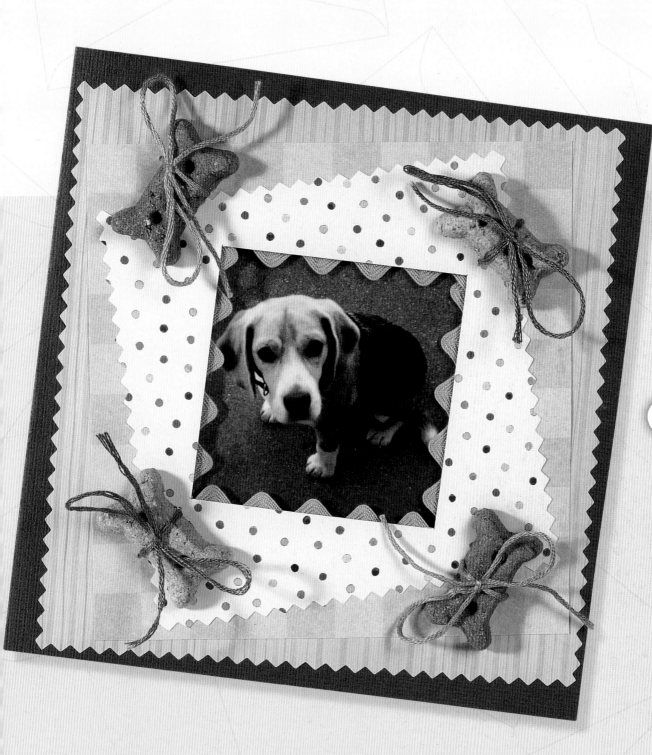

Our House

Faded wallpaper and vintage crocheted lace speak of rooms from another place and time. Damaged and torn photographs can be used dramatically, telling a story about a family and their homestead.

MATERIALS

- 8 x 11-inch (20.3 x 27.9 cm) piece of kraft-colored cardstock
- 3½ x 8 inches (8.9 x 20.3 cm) of "wallpaper" patterned paper
- Large landscape photo and 2 smaller photos of people (damaged photos are fine)
- 4 adhesive foam dots
- 2 or 3 sepia-toned postage stamps
- 1 or 2 postal mark rubber stamps
- Sepia-colored ink pad
- 10-inch (25.4 cm) strip of ecru lace
- Small copper-colored charm

■ STEP BY STEP

1 Fold the cardstock in half to make a 8 x 5½-inch (20.3 x 14 cm) card.

2 Use deckled-edge scissors to trim ⅛ inch (3 mm) off the bottom edge of the card face.

3 Tear ½ inch (1.3 cm) off the long side of the patterned paper. Align the larger piece of patterned paper to the top edge of the card face, and glue it down. Roll with a brayer.

4 Glue the smaller torn paper strip along the bottom edge of the inside of the card with the torn edge facing inwards. A ⅛-inch (3 mm) border should show when the card is closed.

5 Glue the large photo down on the card face. It can be off-center, but it should be straight.

6 Crop the two smaller photos by tearing the edges off in a rectangle around the people you want to feature.

7 Glue one of the small photos in the lower right-hand corner, overlapping the landscape.

8 Apply four adhesive foam dots to the back of the other small photo and press it down towards the upper left-hand portion of the card.

9 Balance the card composition by applying two or three postage stamps in open areas.

10 Use the sepia ink to stamp one or two postal marks over the stamps.

11 Swipe all four edges of the card face with the sepia ink pad for an antiqued look.

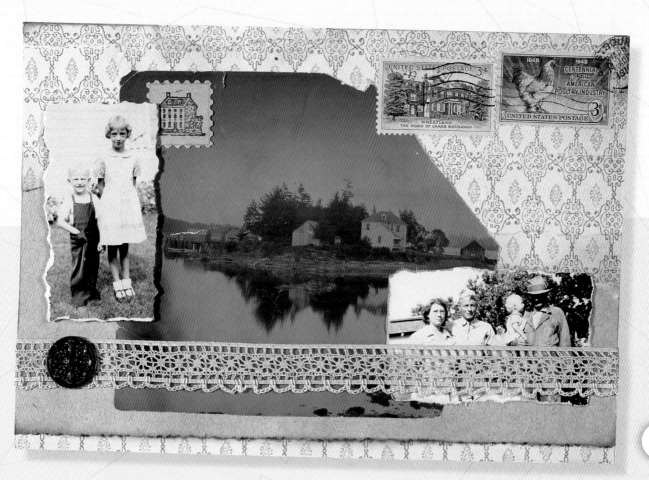

12 Wrap the ecru lace around the horizontal edges of the card, so that both ends are on the inside front of the card. Tack each end down with double-sided tape.

13 Use industrial glue to adhere the copper charm on top of the lace.

TIP

You can make your own "postage" stamps by stamping favorite images on scrap paper, drawing a square or rectangular border around them, and cutting them out with stamp-edged decorative scissors.

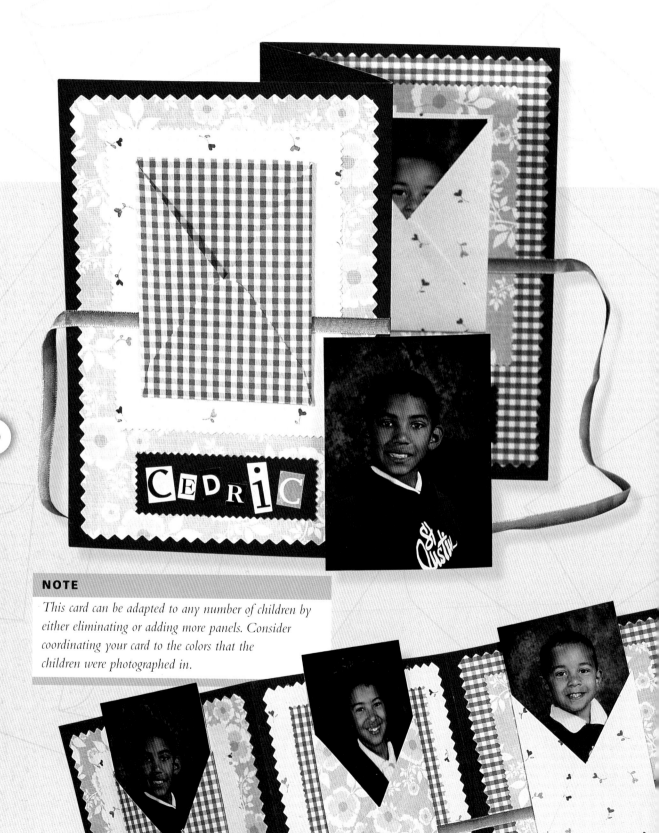

NOTE

This card can be adapted to any number of children by either eliminating or adding more panels. Consider coordinating your card to the colors that the children were photographed in.

Back to School

September already? This tri-fold pocket card is a great way to send out school photos to friends and relatives. The recipient can either remove the photos, or tape them on top of the pockets for an instant desktop frame.

MATERIALS

- 6½ x 13½-inch (16.5 x 34.3 cm) piece of blue cardstock
- Envelope template (page 126)
- 3 different patterned blue pieces of paper, each 4¾ x 5½ inches (12.1 x 14 cm)
- 3 different patterned blue pieces of paper, each 4½ x 6½ inches (11.4 x 16.5 cm)
- 3 different patterned blue pieces of paper, each 3½ x 4½ inches (8.9 x 11.4 cm)
- 30 inches (76.2 cm) of blue ribbon, ¼ inch (6 mm) wide
- 3 school photos trimmed to 2¼ x 3 inches (5.7 x 7.6 cm)
- 1 x 8-inch (2.5 x 20.3 cm) strip of blue cardstock
- Cutout letters for children's names

STEP BY STEP

1 Measure 4½ inches (11.4 cm) in from each short side of your blue cardstock, score and fold in a "Z" shape.

2 Copy and cut out the envelope template found on page 126. Trace the envelope shape on each of the 4¾ x 5½-inch (12.1 x 14 cm) pieces of blue patterned paper. Cut them out with a mat knife and metal ruler.

3 Score the inside edge of each envelope flap. Fold the two long sides of the envelope in first, then fold the bottom flap up, gluing it over the two side flaps. Fold the top flap in (but do not glue down) to form a pocket.

4 Use regular pinking shears to trim ¼ inch (6 mm) off of each side of the three largest pieces of blue papers.

5 Use mini pinking shears to trim ⅛ inch (3 mm) off each of the smallest pieces of blue papers.

6 Glue each of the largest blue papers in the center of each panel of your Z folded card.

7 Measure up 1¾ inches (4.4 cm) from the bottom of the card, and glue each of the smaller blue papers in the upper center of each larger paper, mixing the patterns.

8 Make a light pencil rule across the horizontal center of the card.

Cut a thin 13½-inch-long (34.3 cm) strip of double-sided tape, and lay it down across the pencil line. Match up the center of the ribbon with the center of the tape line, and stick the ribbon down across the card.

9 Glue an envelope pocket in the center of each smaller piece of blue patterned paper, again mixing the patterns so that all three are different on each panel. Insert a child's photo into one of the pockets.

10 Trim both 8-inch (20.3 cm) sides of the blue cardstock strip with mini pinking shears.

11 Glue the cutout letters onto the blue strip to create each child's name.

12 Cut the names apart with mini pinking shears, and tape down the appropriate name placards on the space below each envelope.

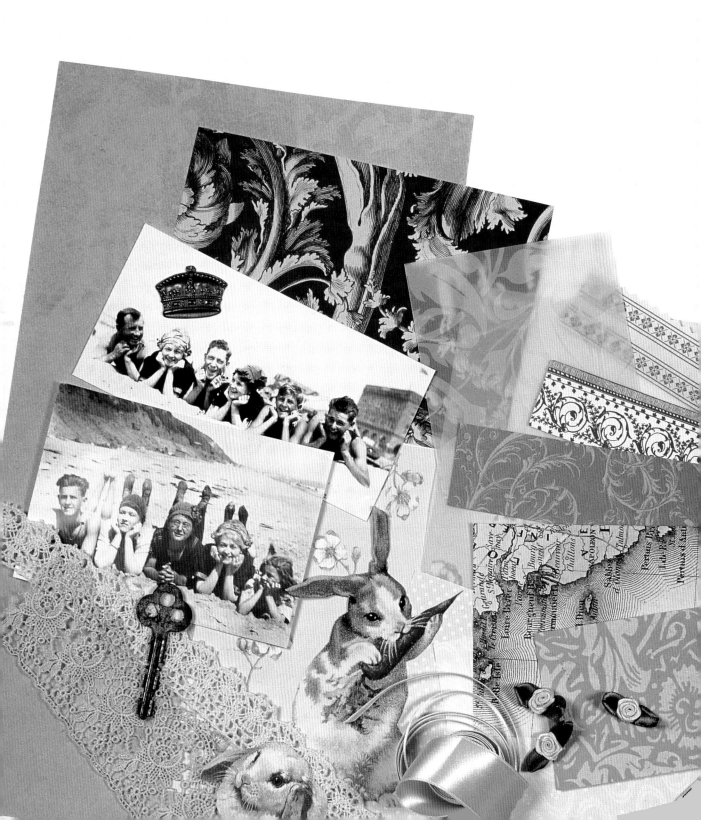

Embellishments serve more than one purpose. They add a "precious" quality to your card that makes the recipient want to savor and to save it. They also add a lovely dimensional quality that is inviting to the touch.

Embellishments can be drawn from a wide source of materials, giving the creator a chance to use interesting elements that might not ordinarily be found on a greeting card. Embellishments can come from a variety of places, the only common requisite being that they are flat enough to fit in a mailable envelope! I love using little treasures from nature: feathers, sand dollars, shells, pressed leaves or flowers, and beautiful shades of sea glass. Other pieces I am fond of including are velvet leaves, unique buttons, fabric flowers, small keys, and foreign coins. But my favorite embellishments of all are ribbons and lace. They can be used both as small accents and as a more important design element that helps to tie all the paper layers together.

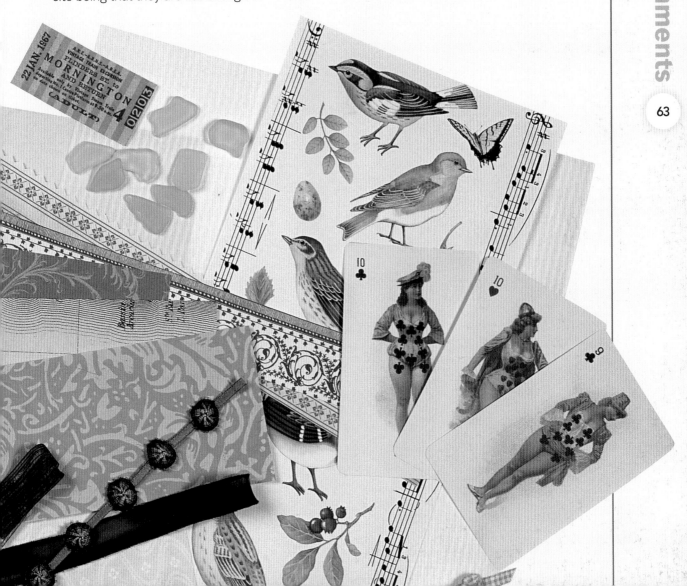

Pink Cake

The glow of candles atop a lovingly baked cake can evoke many special memories. Recreate those feelings with paper candles (complete with painted gold flames) planted on a cake festooned in scalloped rows of lace and embroidered trim "icing."

MATERIALS

- 7 x 10-inch (17.8 x 25.4 cm) piece of pale pink cardstock
- 5 different strips of pink-patterned paper, each ¾ x 5 inches (1.9 x 12.7 cm)
- 1-inch (2.5 cm) circle template
- 7-inch (17.8 cm) piece of trim with florets or rosettes
- 2 pieces of 7-inch (17.8 cm) embroidered trim, preferably with scalloped edges
- Thin gold felt tip pen
- Gold embossing powder, embossing ink pen, embossing pad, and heat gun

■ STEP BY STEP

1 Fold the cardstock to make a 5 x 7-inch (12.7 x 17.8 cm) card.

2 To create the candles, cut each strip of pink-patterned paper so it is slightly tapered at the top. Make the center candle about 4½ inches (11.4 cm) tall; the rest should be slightly shorter in descending order.

3 Mark 5 inches (12.7 cm) off in 1-inch (2.5 cm) increments along the top of the card. Line up your 1-inch (2.5 cm) circle template at each mark, and lightly draw a half circle. Use the pinking shears to cut five half circles across the top of your card.

4 Measure 1½ inches (3.8 cm) up from the bottom of the card, and lightly draw a horizontal line. This will mark your placement for the floret ribbon.

5 Fold over ½ inch (1.3 cm) on one end of each piece of trim, and use double-sided tape to secure it back on itself so the cut edge won't be visible.

6 Using a ruler and mat knife, cut a very thin 5-inch (12.7 cm) strip of double-sided tape, and tape it down over the pencil line.

7 Starting with the folded end, press the floret ribbon down on the tape strip, then fold and tape the other end down on the tape strip so that neither cut end shows. Repeat this process for

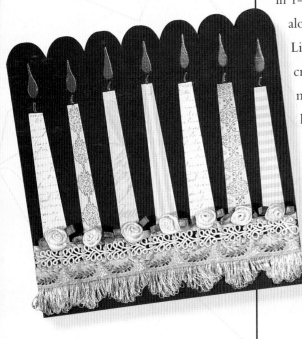

NOTE

For a more formal version, just substitute the pinks with more neutral colors.

the other two pieces of trim, layering one on the other and filling up the 1½-inch (3.8 cm) bottom margin (like cake frosting).

8 Glue down one paper candle behind each floret (you may need to adjust the number of candles if your flowers are spaced differently). The center candle should be the tallest, with the others in descending order.

9 Draw a small arc with the gold felt pen at the top of each candle to create a wick.

10 Use the embossing ink pen to draw an elongated teardrop shape above the first wick.

Sprinkle with gold powder, neaten up any stray edges with a paintbrush, and heat with the heat gun until shiny. Repeat this process with the four other candles.

Song Bird

The song of a lark, the scent of apple blossoms, the pink of a dawn sky; this ode to spring is beautifully embellished by luxurious satin ribbon and a swath of antique lace, giving this card a truly feminine appeal.

EMBELLISHMENTS

MATERIALS

- 8½ x 11-inch (21.6 x 27.9 cm) piece of pale pink cardstock
- 5½ x 8½-inch (14 x 21.6 cm) piece of pink floral-patterned paper
- ½ x 8½-inch (1.3 x 21.6 cm) strip of black paper
- 4 x 8½-inch (10.2 x 21.6 cm) piece of old sheet music
- 5 pictures of songbirds
- 3 x 5½-inch (7.6 x 14 cm) strip of old sheet music
- 10 inches (25.4 cm) of ecru lace, 2 to 2½ inches (5 to 6.4 cm) wide
- 20 inches (50.8 cm) of pink satin ribbon, 1 inch (2.5 cm) wide

■ STEP BY STEP

1 Fold the cardstock in half to make a 5½ x 8½-inch (14 x 21.6 cm) card.

2 Roughly tear off about ½ inch (1.3 cm) from one long side of the pink floral paper. From the torn leftovers, trim out one flower to be used later as an accent.

3 Line up the long straight edge of the pink floral paper with the spine of the card, and glue it down. Roll well with a brayer.

4 Cut the strip of black paper in half with regular pinking shears.

5 Fold the 4 x 8½-inch (10.2 x 21.6 cm) piece of sheet music in half vertically. Glue one of the thin black strips behind the long right-hand edge of the folded sheet music piece.

6 Fit the spine of the card into the folded sheet music. Glue the back of the sheet music piece to the back of the card.

7 Cut out all of the birds. Tuck three of the birds under the sheet music flap, cutting one bird's wing so it flaps over the top of the sheet music. Glue the birds down to the card face, leaving the one wing and one bird's head unglued.

8 Trim the sides of the small strip of sheet music with pinking shears to form a long skinny "V" shape. Tuck this strip under the loose bird's head and glue the snippet of music down, trimming off at the card edge.

9 Glue down the sheet music flap, then glue down the bird's wing and head. Roll both the

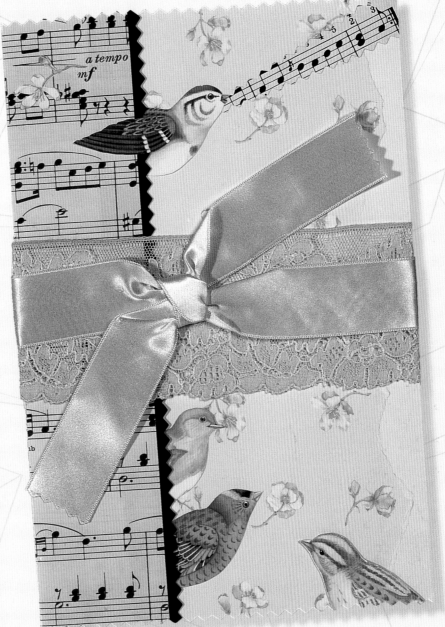

NOTE

*See page 122 for
inside treatment ideas.*

music flap and the three
birds thoroughly with
the brayer.

10 Glue down the fourth
bird so it bleeds off the
bottom edge of the card.
Glue down the small floral
cut out.

11 Measure down 3 inches
(7.6 cm) from the top of the
card's spine, and with a mat knife
and metal ruler, cut a 2½-inch
(6.4 cm) slot just slightly behind
the fold of the spine.

12 Gently thread the lace
through the slot with both
ends on the inside of the card.
Tape one end down with
double-sided tape, then tape
the other end on top of the first.

13 Thread the pink ribbon
through the same slot, but
have both ends meet on the
front of the card. Tie the
ribbon in a nice fat knot and
trim each end with the
pinking shears.

Rooster Tag

A proud farmyard rooster struts his stuff across a country palette of brown, orange, and rust. The folded tag-shaped card is accented by a 1940's sepia-colored postage stamp and a real feather.

MATERIALS

- 8-inch-square (20.3 cm) piece of pumpkin-orange cardstock
- 3 x 4-inch (7.6 x 10.2 cm) piece of decorative script paper
- Large crackle rubber stamp
- Watermark stamp pad
- Sepia watercolor paint and watercolor brush
- 1-inch (2.5 cm) circle paper punch
- 2 x 4-inch (5 x 10.2 cm) piece of orange or brown textured paper
- 2-inch (5 cm) scrap of brown paper
- ¼-inch (6 mm) hole punch
- 8 inches (20.3 cm) of rust-colored ribbon, ⅝ inch (1.6 cm) wide
- Large rooster sticker
- Sepia postage stamp
- Brown feather (no longer than 4 inches [10.2 cm])
- 10 inches (25.4 cm) of brown satin ribbon, ⅜ inch (9.5 mm) wide

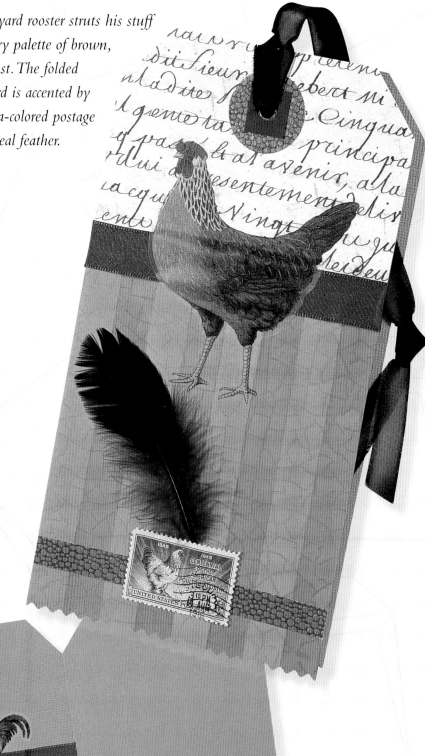

STEP BY STEP

1 Fold the pumpkin-colored cardstock to make a 4 x 8-inch (10.2 x 20.3 cm) card.

2 Align the script paper to the top third of the card, then glue it down and roll with a brayer. Measure ¾ inch (1.9 cm) from each of the two top corners, and trim off each corner at an angle to form a tag shape.

3 Ink the crackle stamp with the watermark pad, and stamp the pattern to cover all of the remaining pumpkin-colored paper on the face of the card.

4 Measure ½-inch (1.3 cm) vertical stripes across the top of the pumpkin paper, just below the script paper line. Paint every other stripe with a pale sepia watercolor wash, and allow to dry thoroughly.

5 Punch out a 1-inch (2.5 cm) circle from the textured paper, then cut one ⅜ x 4-inch (9.5 mm x 10.2 cm) strip from the paper.

6 Cut out a ⅝-inch (1.6 cm) brown paper square, and glue it onto the center of the 1-inch (2.5 cm) circle. Glue the circle down on the card front, ½ inch (1.3 cm) down from the top center. Punch out a ¼-inch (6 mm) hole in the center of this circle through the card front.

7 Cut a ¾-inch (1.9 cm) slot just behind the spine of the card, centering it where the script paper and crackle pattern meet.

8 Thread the rust-colored ribbon through the slot, so that both ends meet on the front center of the card. Tape each end down with double-sided tape.

9 Place the rooster so it is centered over the ribbon ends, and stick or glue it down.

10 Glue the textured paper strip on the bottom portion of the card. Use the pinking shears to trim off the very bottom edge of the card, cutting through both sides of the card.

11 Tape the feather to the back of the postage stamp, and then center and tape the stamp and feather on top of the textured paper strip.

12 Thread the brown satin ribbon through the hole in the card and tie, creating a hanger.

Bay of Biscay

By the sea, by the sea, by the beautiful sea…Blue waves of paper and vellum wash against a torn beach map, which is uniquely accented by a scattering of "found" aqua-blue sea glass.

EMBELLISHMENTS

MATERIALS

- 7 x 11-inch (17.8 x 27.9 cm) piece of pale aqua cardstock
- Postal wave rubber stamp
- Watermark stamp pad
- Beach photo, approximately 2½ x 5½ inches (6.4 x 14 cm)
- 5 x 7-inch (12.7 x 17.8 cm) piece of light blue vellum
- 2½ x 7-inch (6.4 x 17.8 cm) piece of a coastline map
- Compass rubber stamp
- Black stamp pad
- 7 or 8 small pieces of fairly flat colored beach glass

■ STEP BY STEP

1 Fold the aqua cardstock to make a 5½ x 7-inch (14 x 17.8 cm) card.

2 Ink the postal wave rubber stamp with the watermark pad, and stamp wave images horizontally over the entire face of the card; some overlapping is fine.

3 Measure the central image in your photograph that you would like framed. In pencil, draw a rectangle centered on your card, about 1 inch (2.5 cm) down from the top edge.

4 Add ½ inch (1.3 cm) to each side of your rectangle measurement. This will be the final size of your blue vellum frame. Draw this larger measurement lightly on the vellum sheet, and carefully tear it out on all four sides.

5 Glue the torn vellum piece onto the card face, lining up the penciled rectangles, and roll well with a brayer.

6 Use the mat knife and metal ruler to cut out the penciled window, cutting through both the vellum and the cardstock to frame your photograph.

7 Center and straighten the photo behind the window, and glue it down on the inside of the card. Roll it with the brayer.

8 Tear your piece of coastline map on a horizontal diagonal from lower left to upper right. Glue the lower piece down to the lower right-hand corner, and roll with brayer.

9 Tear three strips of vellum, making sure you have at least one straight edge on each piece.

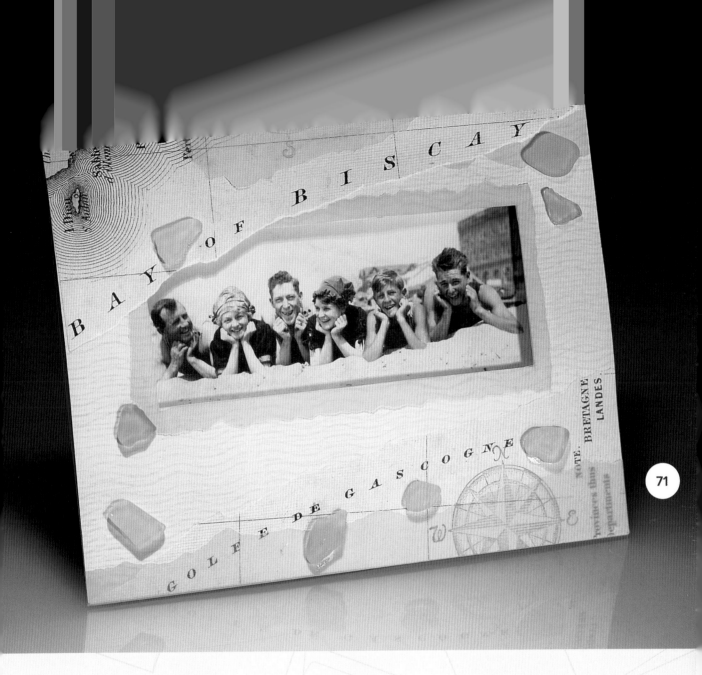

Layer one long piece over the map at the bottom. Glue it down and roll flat.

10 Glue down a second vellum strip in the upper right-hand corner, then attach the upper map piece over this. Glue the final piece of vellum over the map along the top edge, to create a nice feeling of overlapping waves. Roll all the layered pieces with your brayer.

11 Ink the compass rubber stamp with black ink. Stamp it out once on scratch paper, then stamp your image in a blank spot on your collage.

12 Arrange the bits of sea glass, and glue them down one by one using small amounts of industrial glue. Let them sit overnight to dry.

Letter in Hand

Lacy cuffs and calling cards speak of etiquette from another era. With this card you can hand-deliver your own gracious note in a vellum envelope. An authentic brass key accents a ribbon of crushed velvet.

MATERIALS

- 8½ x 11-inch (21.6 x 27.9 cm) piece of buff cardstock
- 5¼ x 8½-inch (13.3 x 21.6 cm) piece of black and beige floral-patterned paper
- Envelope template (page 126)
- 6 x 8-inch (15.2 x 20.3 cm) piece of buff-colored vellum
- Large rubber stamp of a hand
- Black stamp pad
- 2½ x 5-inch (6.4 x 12.7 cm) piece of buff-colored paper
- Pink pencil
- 10 inches (25.4 cm) of salmon crushed-velvet ribbon, 1 inch (2.5 cm) wide
- 5 inches (12.7 cm) of wide ecru lace
- 2 x 3-inch (5 x 7.6 cm) piece of cream cardstock
- Vintage brass key and one small antiqued metal charm

■ STEP BY STEP

1 Fold the buff cardstock to make a 5½ x 8½-inch (14 x 21.6 cm) card.

2 Trim ¼ inch (6 mm) off of each side of the patterned paper with Victorian-edged scissors. Glue it to the center of the card front, and roll with a brayer.

3 Trace the envelope template on page 126 onto your sheet of vellum. Cut out and fold in all four corners. Glue the bottom flap on top of the side flaps, leaving the top open.

4 Ink your hand rubber stamp with the black ink pad, and stamp onto the buff paper.

5 Color in any fingernails with a pink pencil. Carefully cut out the hand, then cut the line between the thumb and forefinger so the envelope can be inserted.

6 Cut a 3-inch (7.6 cm) piece of the velvet ribbon. Press a ¼-inch (6 mm) strip of double-sided tape along one edge of the ribbon piece. Gather up 5 inches (12.7 cm) of lace to fit the 3 inches (7.6 cm) of ribbon, and press down onto the tape, forming a ruffled cuff.

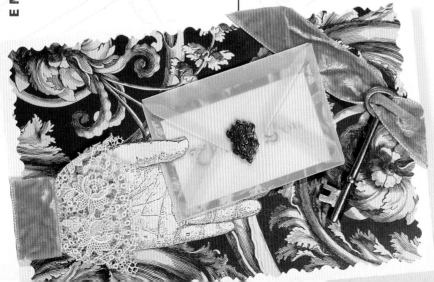

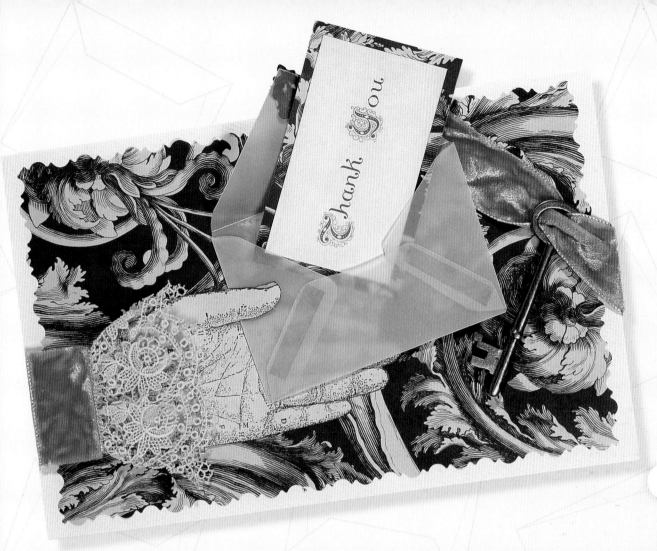

7 Wrap the "cuff" around the base of the hand, and tape down securely on the backside. Tape the cuff down with double-sided tape and glue the hand down with a glue stick, leaving the thumb free.

8 Print or write a message on the cream-colored cardstock, and tuck into the envelope. Slip the envelope under the thumb, and tack the envelope down with a piece of tape in the center of the envelope front. The flaps should be facing outward.

9 Use a doubled-over piece of tape to stick the metal charm onto the top flap of the envelope. It will act as a weight to keep the envelope closed.

10 Thread the key through the remaining piece of ribbon. Fold the ribbon ends around the upper right corner of the card, and tack each end down with double-sided tape.

Queens of the Theater

Her Majesty requests the honor of your presence at a royal theater presentation. Curtain up! One of these charming ladies will be crowned queen with a gold charm crown amidst the sparkle of a starry sequin backdrop.

MATERIALS

- 8½ x 11-inch (21.6 x 27.9 cm) piece of dark red cardstock
- Diamond rubber stamp
- Watermark stamp pad
- Drapery swag template (page 126)
- 3 x 4½-inch (7.6 x 11.4 cm) piece of fancy red-patterned paper
- Butterfly sticker
- 2 strips of paper with different border designs, each 1 x 4½ inches (2.5 x 11.4 cm)
- 2 strips of different red-patterned papers, each 3 x 8½ inches (7.6 x 21.6 cm)
- 5 or 6 small pieces of queen or theater-related memorabilia
- 4 foam adhesive dots
- 3 costumed paper figures, 3 to 3½ inches (7.6 x 8.9 cm) tall
- Gold metal "crown" charm
- About 24 gold star sequins
- 22 inches (55.9 cm) of rust-colored silk ribbon, ⅜ inches (9.5 mm) wide

■ STEP BY STEP

1 Fold the cardstock to make a 5½ x 8½-inch (14 x 21.6 cm) card.

2 Ink the diamond rubber stamp with the watermark pad, and stamp diamonds on the entire front surface of the card. Imperfect alignments are fine.

3 With a pencil, trace the drapery swag template on page 126 onto your fancy red–patterned paper. Cut out and glue along the top and right-hand corners, rolling flat with a brayer.

4 Stick the butterfly sticker just above the center point of your curtain.

5 Glue your two 1-inch (2.5 cm) border strips along the bottom right edge of the card, one just above the other so their edges meet. Roll them down with the brayer. This will be the "floor."

6 Vertically fold each of the 3 x 8½-inch (7.6 x 21.6 cm) strips. Tear about ½ inch (1.3 cm) off each long edge of just one of the pieces. Glue down the untorn piece, fitting the spine of the card into the fold of the paper, and roll with the brayer. Repeat with the torn piece, layering it on top of the first piece to create a book binding effect. Roll both with the brayer.

7 Scatter your memorabilia pieces down the edge of this binding, tucking one under another. Glue each one down, saving your favorite piece until last. Use four foam dots on the last piece so it floats above the others.

8 Carefully cut out your figures and arrange them on your stage floor, then glue them down.

9 Use a dab of industrial glue on the back of the crown, and glue it above the head of one of the characters.

10 Sprinkle the star sequins all about the stage area, and glue down one by one with small dots of bonding glue.

11 Finish the card by tying the silk ribbon around the far left-hand edge of the card. Knot the ends together at the bottom, trim in a deep "V," and let them hang loose.

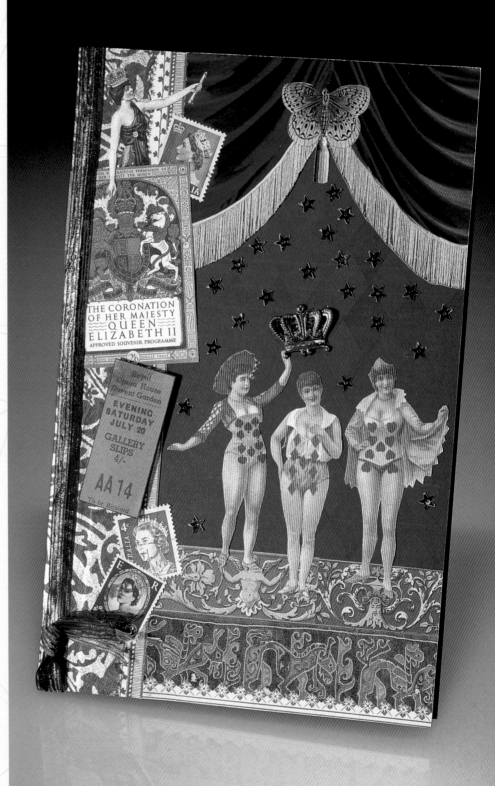

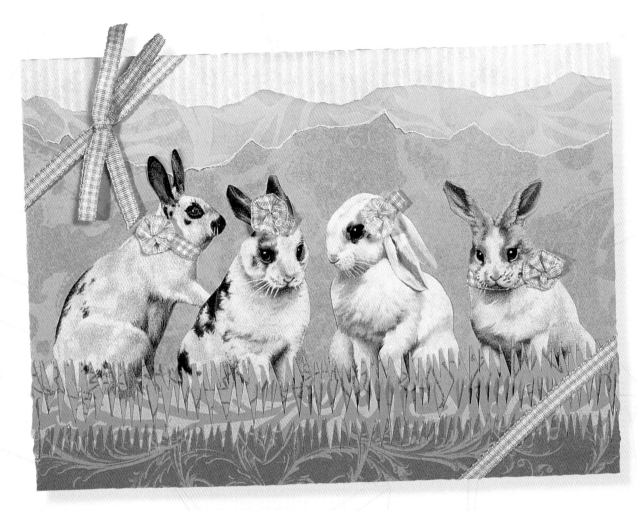

Les Lapines

Hippety-hop. Here are four bunnies nestled in the grass, all dressed up in their spring finery. A torn paper sky of blue and rows of cut green paper grass make a perfect spot for these rosette-bedecked rabbits.

MATERIALS

- 7 x 10-inch (17.8 x 25.4 cm) piece of light blue patterned cardstock
- 2 strips of different patterned white vellum papers, each 1½ x 7 inches (3.8 x 17.8 cm)
- 4 bunny pictures (either vintage or modern)
- 6 inches (15.2 cm) of gingham rosette ribbon with a minimum of 4 rosettes
- 3 strips of different patterned green papers, each 1½ x 7 inches (3.8 x 17.8 cm)
- 2 feet (61 cm) of narrow light blue gingham ribbon

■ STEP BY STEP

1 Fold the cardstock to make a 7 x 5-inch (17.8 x 12.7 cm) card.

2 Tear one long side of each piece of white vellum to create a cloud effect. Layer one row of "clouds" under the other, glue down, and roll with a brayer. Trim off any excess paper.

3 Cut out the bunnies with sharp scissors. Use a mat knife to cut under a bunny's chin if you wish it to have a ribbon around its neck.

4 Wrap a small segment of rosette ribbon around each bunny's neck or create a rosette and small loop for their ears. Secure them with very small pieces of double-sided tape.

5 Draw a light pencil line 1 inch (2.5 cm) up from the bottom of the card. Glue all four bunnies in a row along this line. Roll with the brayer.

6 Using sharp scissors, cut a series of deep "V" shapes on one long side of each strip of green paper.

7 Layer the green papers one on top of each other, spaced about ¼ inch (6 mm) apart. Glue them down from top to bottom and trim any excess. Follow the direction of the grass and gently roll them with the brayer.

8 Wrap the gingham ribbon around the upper left and lower right corners of your card. Make pencil marks where the ribbon crosses the top fold. Use the mat knife to cut a small slit for the ribbon directly behind the fold. Thread the ribbon through the slit, and tie in a bow. Trim the ends at a slant.

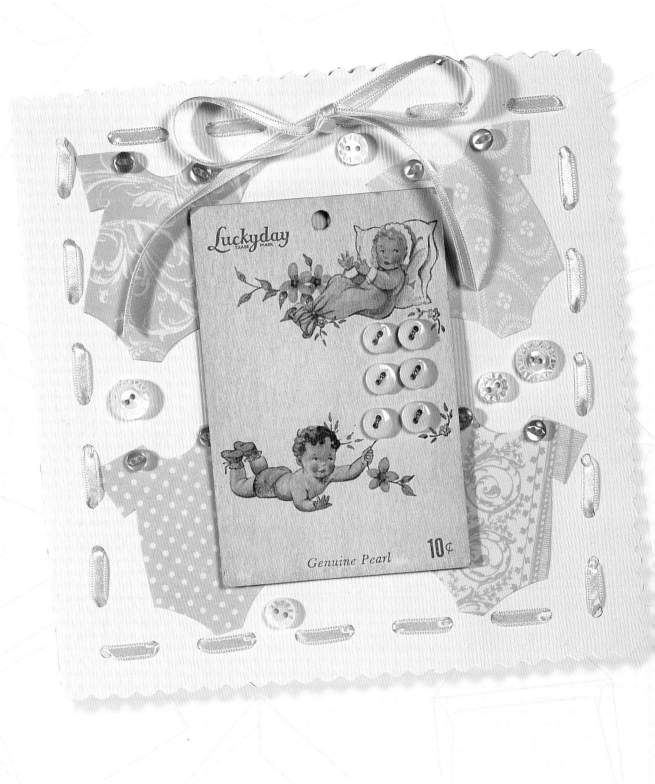

Baby Buttons

Button, button, who's got the button? Centered around a card of vintage baby buttons, the scalloped edge and woven ribbon trim lend just the right note of sweetness to this charming baby card.

MATERIALS

- 6 x 12-inch (15.2 x 30.5 cm) piece of cream-colored cardstock
- ⅛-inch (3 mm) hole punch
- Embroidery needle
- 3 feet of cream-colored satin ribbon, ⅛ inch (3 mm) wide
- Onesies pattern (page 124)
- 2 patterned baby-blue pieces of paper, 2 x 2½ inches (5 x 6.4 cm)
- 2 patterened pink pieces of paper, 2 x 2½ inches (5 x 6.4 cm)
- 13 baby-sized buttons in pink, blue, and off-white
- 4 foam adhesive dots
- Card of baby buttons, approximately 2½ x 3¾ inches (6.4 x 9.5 cm)

STEP BY STEP

1 Fold the cream-colored cardstock in half to make a 6-inch-square (15.2 cm) card.

2 Measure ½ inch (1.3 cm) in from the edge on all four sides of the card front, and lightly rule with a pencil. Mark off ½-inch (1.3 cm) increments all around this penciled square.

3 Use scallop-edge scissors to trim off a very thin border from the card's three open sides, cutting through both card layers.

4 Punch ⅛-inch (3 mm) holes through the card face at all the pencil tick marks. Note that you will need to use an eyelet-setting punch along the center portion of the card's spine.

5 Erase all pencil lines from the card front before beginning the next step.

6 Starting at the top center and going from front to back, use an embroidery needle to thread the ribbon in and out of the holes around all four edges of the card. Tie the loose ends into a bow, and trim the ends in a slant.

7 Use a pencil to trace the onesie template on page 124

onto each of the pink and blue papers, then cut them out.

8 Arrange the four onesies on the front of the card. Glue down and roll them with the brayer.

9 Attach tiny amounts of double-sided tape to the back of each button and firmly stick down on each of the onesie shoulders.

10 Apply four foam adhesive dots to the back of the button card and stick it down in the center of the card face, overlapping some of the onesies.

11 Scatter the remaining buttons on the open areas of the card front, and attach firmly with double-sided tape.

EMBELLISHMENTS

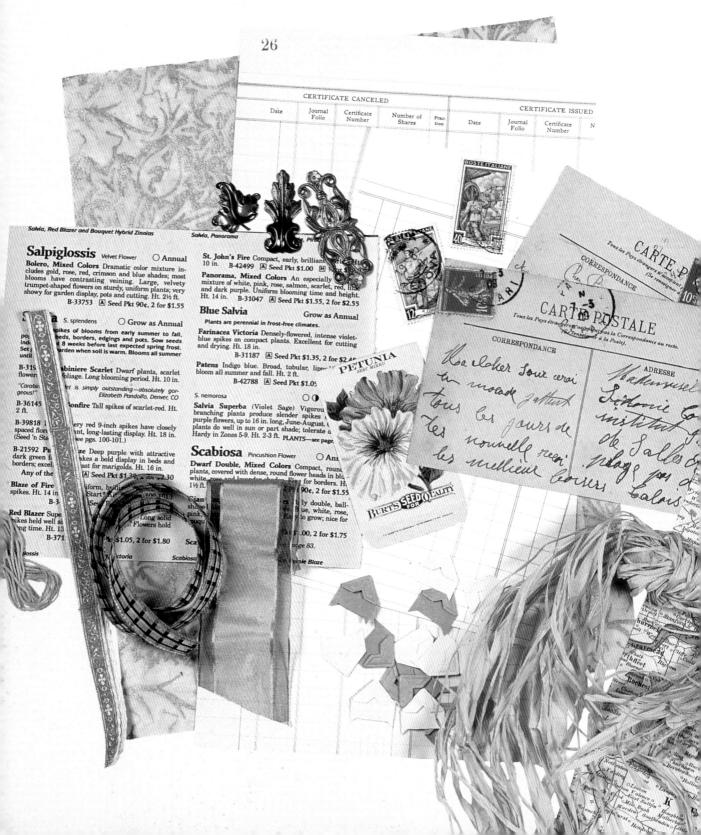

Everybody seems to collect something, and those collections—as well as other interests and passions—can make a great greeting card. Almost anything can be the starting point for a themed card. In this chapter, I've used everything from butterflies to elephants as the basis for a design. In general, you'll need at least three pieces of art pertaining to your subject (one of which can be for your background), and perhaps some kind of interesting embellishment. I've used an "ivory" trinket, an Italian coin, and seed beads on some of my examples. While these cards are tied together by theme, you also need to be aware of complementary colors and composition—just like with any other card design. Whether your chosen theme is roses, clowns, or sailing ships, the sky's the limit!

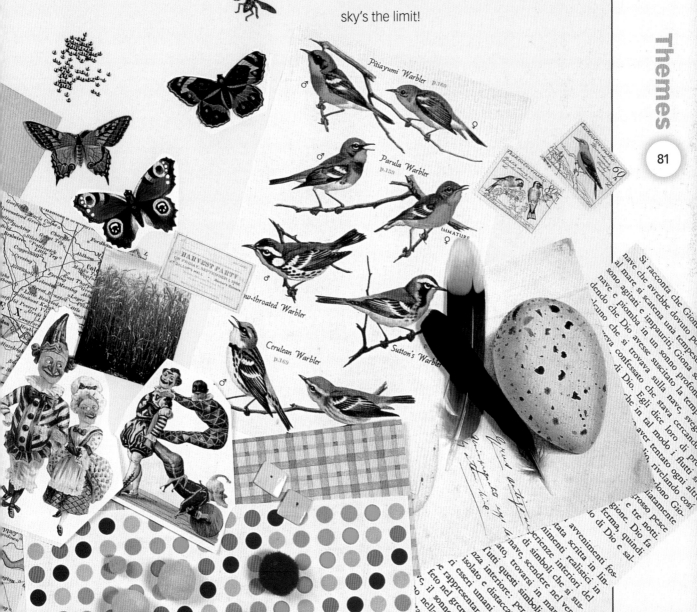

Elephantus

The starting point for this theme card was the wonderful carved elephant bead—the elephant pictures came afterward. The crackle-patterned stamp, like an elephant's hide, seemed a perfect way to tie these pieces together.

MATERIALS

- 5 x 10-inch (12.7 x 25.4 cm) piece of ivory-colored cardstock
- Watermark stamp pad
- Crackle pattern rubber stamp
- 4½-inch-square (11.4 cm) piece of gray cardstock
- 1 x 4½ -inch (2.5 x 11.4 cm) piece of Latin text
- 4 ivory-colored photo corners
- 20 inches (50.8 cm) of natural cotton ribbon, ⅜ inch (9.5 mm) wide
- 2 or 3 elephant images
- Black ink pad
- Alphabet set rubber stamps
- 1 x 2½-inch (2.5 x 6.4 cm) piece of ivory or tan paper
- 1 large and 2 small "ivory" type beads or buttons

■ STEP BY STEP

1 Fold the ivory cardstock in half to make a 5-inch-square (12.7 cm) card.

2 Using the watermark stamp pad, stamp the entire front of the ivory card and one side of the gray cardstock with the crackle pattern stamp.

3 Tear off one 4½-inch (11.4 cm) edge of the Latin text paper, and glue it to the bottom edge of the gray cardstock square, with the torn edge facing upwards.

4 Attach a photo corner to each corner of the gray cardstock square, and glue the assemblage down to the center of the card face.

5 Measure down 1¼ inches (3.2 cm) from the top, along the spine of the card, and cut a ½-inch (1.3 cm) slit just behind the spine for the ribbon to pass through.

6 Cut the ribbon into two 10-inch (25.4 cm) pieces, and thread one piece through the slit with both ends in front, about 1¼ inches (3.2 cm) from the right-hand edge. Tape the ends down with double-sided tape.

7 Wrap the second piece of ribbon around the card vertically. Make both ribbon ends meet at the same spot as the first two, forming a crisscross.

8 Trim the edges of the elephant photo with deckled-edge scissors. Cut out around any larger elephant images. Arrange the images so the ribbon bands do not cover them up, then glue them down on the card face.

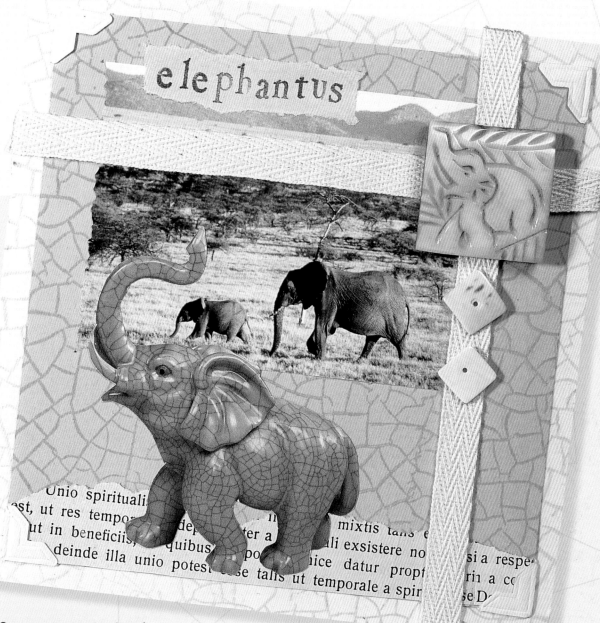

elephantus

Unio spirituali... st, ut res tempor... ut in beneficiis, quibus... deinde illa unio potes... se talis ut temporale a spi... mixtis ta... ali exsistere no... ice datur prop... se D... si a respe... rin a co...

9 Using the black ink pad, stamp out the word "elephantus" (Latin for elephant) on the ivory scrap paper, to soften the color. Tear around all four edges of the word, and glue it on the collage using the project photo as a guide for placement.

10 Use industrial glue to attach the largest bead or button over the crisscross point where the ribbons are taped. Glue down the two smaller beads or buttons on the vertical ribbon.

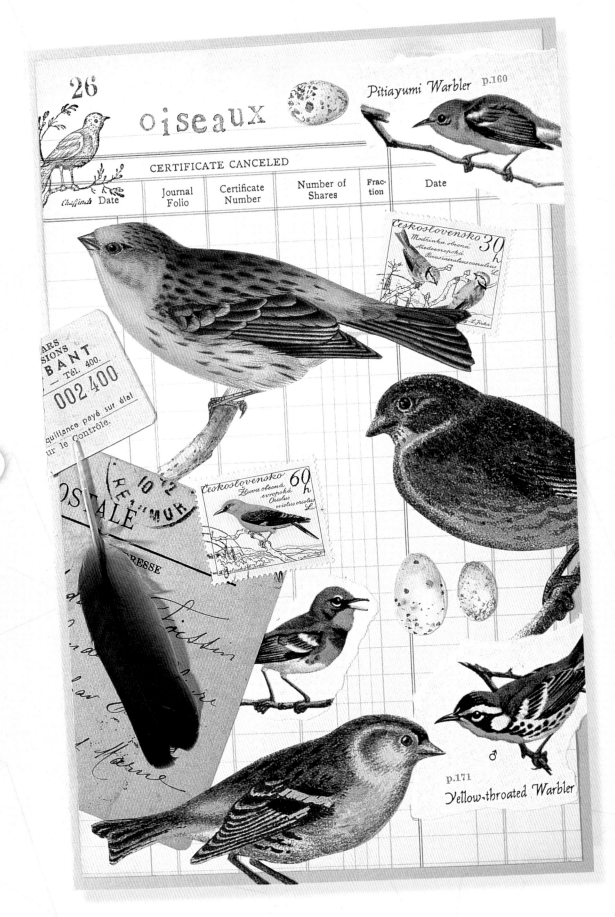

oiseaux

Pitiayumi Warbler p.160

CERTIFICATE CANCELED

	Journal Folio	Certificate Number	Number of Shares	Frac-tion	Date
Date					

Chaffinch

Ceskoslovensko 30 h
Modrinka obecná
stredoevropská
Parus caeruleus caeruleus L.
L. Jirka

BARS
SIONS
BANT
— Tél. 400.
002400
quittance payé sur état
sur le Contrôle.

POSTALE
RÉAUMUR
RESSE

Ceskoslovensko 60 h
Zluva obecná
evropská
Oriolus
oriolus oriolus L.

p.171
Yellow-throated Warbler

Oiseaux

.tiayumi *Warbler* p..

Date

Birds, eggs, and feathers are the subjects of this nature lover's collage. Torn, cut, stamped, or tossed, the large and small images play off each other to both reinforce the theme and create an interesting composition.

MATERIALS

- 8½ x 11-inch (21.6 x 27.9 cm) piece of robin's-egg-blue cardstock
- 5¼ x 8¼-inch (13.3 x 21 cm) piece of bookkeeping paper
- Ecru ink pad
- 6 pictures of birds, 3 large and 3 small
- 5 or 6 other small bird-related images (eggs, nests, etc.)
- 2 old postcards or tickets
- Rubber stamps of birds
- Rubber stamp alphabet set
- Black ink pad
- Small bird feather

■ STEP BY STEP

1 Fold the light blue cardstock in half to make a 5½ x 8½-inch (14 x 21.6 cm) card.

2 Lightly wipe the edges of the bookkeeping paper with the ecru stamp pad to give it an antique look.

3 Center and glue down the bookkeeping paper on the card, then roll with a brayer.

4 Trim out all the larger images, and tear or cut out the smaller pictures. Arrange them on the bookkeeping paper, overlapping some and letting others run off the edge of the card.

5 When you are happy with your layout, glue down the images.

6 Ink the bird rubber stamp with the black stamp pad, and stamp one or two images in the empty spaces on the card.

7 Stamp out the word "oiseaux" ("birds" in French) across the top of the page.

8 Run a thin line of industrial glue along the spine of the feather, and glue it down across the postcard.

NOTE

See page 120 for inside treatment ideas.

p.171

Yellow-throa

Polka Dot Circus

Ladies and gentlemen: in the center ring…a colossal collection of clowns, acrobats, and even a bike-riding elephant! Mini pompoms and dots of different sizes lend a festive air to this colorful circus-themed card.

MATERIALS

- 5 x 10-inch (12.7 x 25.4 cm) piece of sky-blue cardstock
- 1½ x 5-inch (3.8 x 12.7 cm) piece of polka dot paper
- ⅝-inch (1.6 cm) hole punch
- 3 large and 4 small circus stickers
- About 2 dozen dot stickers, ¼-inch (6 mm) diameter
- 5 small poms in matching colors

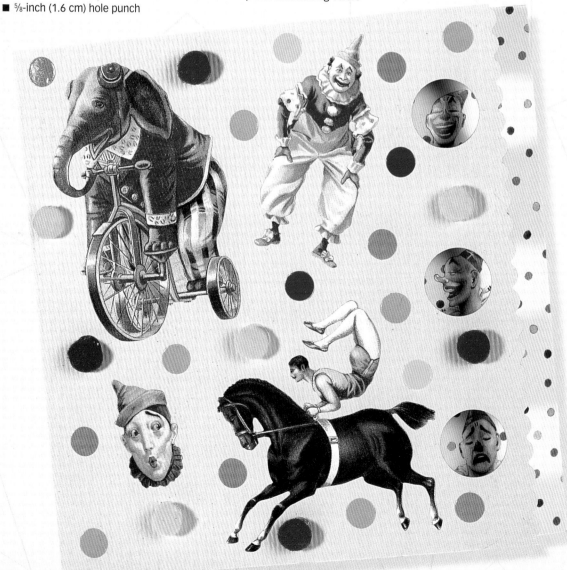

■ STEP BY STEP

1 Fold the cardstock to create a 5-inch (12.7 cm) front, leaving a 5 x 7-inch (12.7 x 17.8 cm) back panel.

2 To make the flap, open the card and measure 2 inches (5 cm) in from the right hand edge of the back of the card and score a vertical line. Fold the scored 2-inch (5 cm) area inward.

3 Glue the piece of polka dot paper onto the outside of the newly formed flap.

4 Measure in ⅜ inch (9.5 mm) from the right-hand edge, and trim off the front card edge with scalloped scissors.

5 Measure ⅝ inch (1.6 cm) in from the blue scalloped edge, and find the center point. Punch out a ⅝-inch (1.6 cm) hole, then measure 1 inch (2.5 cm) to either side of the center hole and punch two more holes, creating a vertical row of three "portholes."

6 Align three of your smaller stickers behind the three holes, and stick them down.

7 Arrange and stick down the remaining circus stickers, then apply the sticker dots in a random pattern, approximately ½ inch (1.3 cm) apart.

8 Use a small amount of industrial glue to apply three or four small pompoms over the coordinating colored dots. Let dry thoroughly.

NOTE

The Old Roses variation on this card adds a bit of rubber stamping and a ribbon band, but otherwise is made exactly the same way.

Harvest Party

Autumnal themes abound in this seasonal collage of wheat images and an invitation to a harvest party. Both the background colors and the generously tied raffia knot reinforce the feeling of fall.

MATERIALS

- 8 x 11-inch (20.3 x 27.9 cm) sheet of cinnamon-colored cardstock
- 4 kraft-colored photo corners
- 5¼ x 8-inch (13.3 x 20.3 cm) piece of fall-colored plaid paper
- Large photo with a fall theme (for background)
- Vintage printed piece: postcard, ticket, invitation, advertisement, etc.
- 2 smaller fall-themed pictures
- ¼-inch (6 mm) hole punch
- 18 inches (45.7 cm) of natural raffia (multiple strands)
- Fairly large copper or brass charm

■ STEP BY STEP

1 Fold the cinnamon-colored cardstock in half to make a 5½ x 8-inch (14 x 20.3 cm) card.

2 Tape a photo corner onto each corner of the plaid paper. Glue the plaid paper onto the center of the card, and then roll with a brayer.

3 Tear a small edge off each side of the large background photo and glue it down in the center of the plaid paper, then roll with the brayer.

4 Arrange and glue down your vintage printed piece, then the two smaller fall images.

5 Measure to the center of the card's spine and, using a ¼-inch (6 mm) hole punch, punch HALF a hole through the spine. When the card is open, there should be a complete hole in the spine's center.

6 Bunch up the raffia, and pull all the strands through the center hole. Tie a nice fat knot in the front, and trim all the ends to about 1½ inches (3.8 cm) long.

7 Use a small amount of industrial glue to attach the metal charm to the card face.

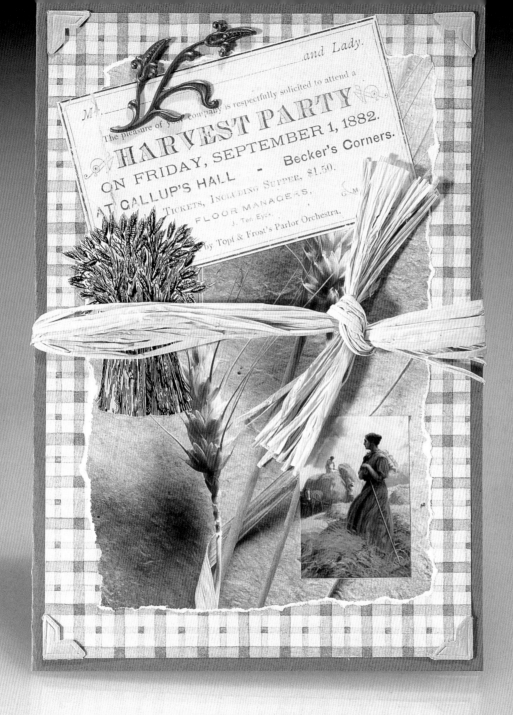

The pleasure of your company is respectfully solicited to attend a

Mr. ...and Lady.

HARVEST PARTY

ON FRIDAY, SEPTEMBER 1, 1882.

AT GALLUP'S HALL - Becker's Corners.

TICKETS, INCLUDING SUPPER, $1.50.

FLOOR MANAGERS,

J. Ten Eyck,

by Topf & Frost's Parlor Orchestra.

Sailing Ships

Stormy life on the high seas gives this card a masculine feeling, while a nautical map provides an apt background for paintings. Stamps of historical sailing ships can be cleverly viewed through ship "portholes."

MATERIALS

- 6 x 12-inch (15.2 x 30.5 cm) piece of dark gray cardstock
- 6 x 8¼-inch (15.2 x 21 cm) piece of black cardstock
- Watermark stamp pad
- Large script pattern rubber stamp
- 2¼ x 5-inch (5.7 x 12.7 cm) piece of a nautical map
- 1-inch (2.5 cm) hole punch
- Seven small pictures or postage stamps featuring ships
- Large picture of a sailing ship, about 3 inches (7.6 cm) square
- Enough scrap cardstock to mount four stamps and the larger picture
- 14 inches (35.6 cm) of ¼-inch-wide (6 mm) blue/gray satin ribbon
- Antique gold or copper charm, preferably square

■ STEP BY STEP

1 Fold the gray cardstock to make a 6-inch-square (15.2 cm) card.

2 On the black cardstock, mark a pencil line 2¼ inches (5.7 cm) in from one of the 6-inch (15.2 cm) sides. Score, then fold inward to form a 2¼ x 6-inch (5.7 x 15.2 cm) flap.

3 Glue the back of the gray card on top of the 6-inch-square (15.2 cm) section of the black cardstock. Roll both with a brayer.

4 Ink your script rubber stamp with watermark ink, and stamp out the pattern over the entire face of the gray card.

5 Tear the nautical map piece in half diagonally. Glue one half to the upper right and one half to the lower left of the card face, aligning the corners. Roll with the brayer.

6 Use the deckled-edge scissors to trim ¼ inch (6 mm) off the right-hand edge of the card face.

7 At the horizontal centerline, measure in ⅝ inch (1.6 cm) from the deckled edge. At this point, punch a 1-inch (2.5 cm) hole with your hole punch. Then measure ¾ inch (1.9 cm) above and below the hole you have just punched, and punch two more holes in line with the first.

NOTE

This "porthole" style of card also works well when featuring a particular subject theme. See Old Roses, page 87, and Polka Dot Circus, page 86, for alternate versions.

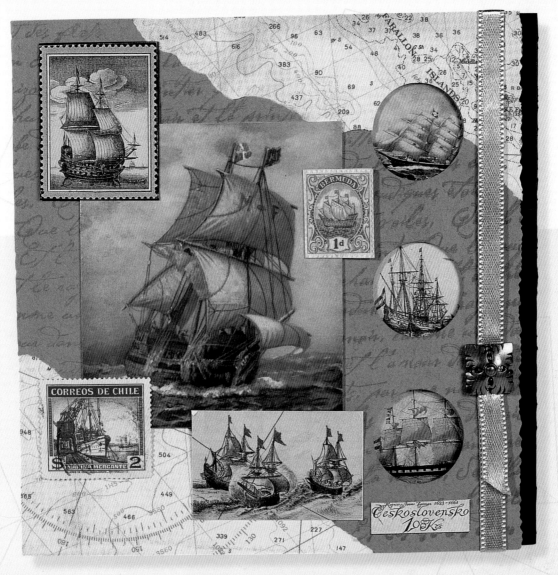

8 Play with the ship pictures to find the three that look best through the "portholes." Line each one up so it is straight, and then glue or stick it down on the black flap.

9 Glue each of the remaining ship images onto the cardstock scraps. Roll with the brayer then trim out each image with a mat knife and metal ruler.

10 Glue the large ship picture down on the card face. Arrange the smaller pictures around it so they overlap its edges, then glue each one down and roll with the brayer.

11 Wrap the ribbon around the card face about ¼ inch (6 mm) in from the deckled edge. Stick one ribbon end down with double-sided tape about 2 inches

(5 cm) up from the bottom of the card, then adhere the second end over the first. Trim the loose end at a slant.

12 Place a dab of industrial glue on the back of the gold metal charm, and glue it over the spot where the ribbons were taped, placing it between the two lower portholes.

LEPIDOPTERA

papilio

Lepidoptera

Forget the pins and mothballs; create your own butterfly collection using a variety of butterfly drawings or photographs. Mounted on a map background and tied with twine, it's a page right out of a collector's journal.

MATERIALS

- 8½ x 11-inch (21.6 x 27.9 cm) piece of cream-colored cardstock
- 5¼ x 8¼-inch (13.3 x 21 cm) piece of antique map paper
- 4¾ x 7¾-inch (12.1 x 19.7 cm) piece of journal paper
- 8 butterfly images of different sizes
- Black colored pencil
- Black ink pad
- Rubber stamp alphabet set
- Small butterfly rubber stamp
- 2 copper or brass eyelets
- Eyelet-setting kit
- 20 inches (50.8 cm) of thin string or twine
- Tarnished metal bug or butterfly charm

■ STEP BY STEP

1 Fold the cardstock in half to make a 5½ x 8½–inch (14 x 21.6 cm) card.

2 Glue the map paper to the center front of the card, and roll it with a brayer.

3 Glue the journal paper to the center of the map paper, and roll with the brayer.

4 Arrange the butterflies in two straight rows, and glue down.

5 Draw in antennae, and number the butterflies with the black colored pencil.

6 Using the black ink pad, stamp the word "Lepidoptera" (Latin for butterfly) across the top, and accent with the butterfly stamp. Stamp the word "papilio" (a type of butterfly) on the lower left side, and accent with another butterfly stamp.

7 Measure 1 inch (2.5 cm) down from the top and 1¾ inches (4.4 cm) in from each side, and mark with a pencil dot. Punch a hole and set an eyelet at each of the pencil dots.

8 Thread your string through the eyelet holes twice, and tie in a bow on the front.

9 Use a dab of industrial glue to glue the charm down next to the word "Lepidoptera."

NOTE

The same types of components were used to make the Oiseaux ("birds" in French) card (pg 84). The journal paper was swapped out for a page of a bookkeeping ledger.

THEMES

Venezia

Gondolas, canals, and arched bridges abound in these romantic Venetian images. Travel photos and souvenirs make perfect bits and pieces for a vacation-themed card. Just pick a complementary background color, and the sense of place will tie it all together.

MATERIALS

- 8 x 9¼-inch (20.3 x 23.5 cm) piece of cobalt-green cardstock
- 8 x 9¼-inch (20.3 x 23.5 cm) piece of aqua and gold rice paper
- 2½ x 9¼-inch (6.4 x 23.5 cm) piece of Italian text paper
- 3 colored scenes of Italy, each about 2 x 2½ inches (5 x 6.4 cm)
- 3 Italian stamps in coordinating colors
- 11 inches (27.9 cm) of two-tone organdy ribbon, 1½ inches (3.8 cm) wide
- Large tarnished gold charm
- Gold Italian coin

■ STEP BY STEP

1 Fold the cobalt-green cardstock in half to make a 4 x 9¼-inch (10.2 x 23.5 cm) card.

2 Tear off ½ inch (1.3 cm) of each 9¼ inch (23.5 cm) side of the rice paper.

3 Tear off ¼ inch (6 mm) of each 9¼ inch (23.5 cm) side of the Italian text paper.

4 The rice and text papers fold over to decorate the back of this card. To do this, fold the papers in half vertically. Fit the spine of the card into the fold of the rice paper and glue down both sides, rolling with a brayer. Repeat with the Italian text paper.

5 Arrange the three Italian scenes and stamps so they cascade down the rice paper, then glue them down one by one.

6 Measure up 3 inches (7.6 cm) from the bottom of the card's spine, and cut a vertical 1½-inch (3.8 cm) slot just slightly behind the spine of the card.

7 Gently pull the ribbon through the slot. Tape down the left-hand end with double-sided tape, then tape the right side over the left, placing the second tape piece directly over the first. Trim the loose end in a shallow "V."

8 Use a generous dab of industrial glue to attach the charm on top of the tape pieces.

9 Double over a piece of double-sided tape, and stick down the Italian coin in a blank spot on your collage.

Petunia Packet

This striking vintage seed packet becomes the focal point for a gardening-themed collage. The background is a page taken from a seed catalog, while black seed beads, standing in for the real thing, spill out from the open package.

MATERIALS

- 8½ x 11 inches (21.6 x 27.9 cm) piece of pink cardstock
- Gardening catalog page, 5¼ x 8½ inches (13.3 x 21.6 cm)
- Pink watercolor paint and small brush
- 2 pieces of vintage floral art
- Attractive pink seed packet
- ⅛-inch (3 mm) hole punch
- 10 inches (25.4 cm) of pink and black plaid ribbon, ⅝ inch (1.6 cm) wide
- Silver floral or garden-themed charm
- Approximately 48 small black glass seed beads

■ STEP BY STEP

1 Fold the pink cardstock to make a 5½ x 8½-inch (14 x 21.6 cm) card.

2 With a pencil and ruler, mark ½-inch (1.3 cm) vertical stripes across the entire catalog page.

3 Paint every other stripe with pink watercolor paint. The stripes needn't be perfect; they are more for adding color. Let the page dry thoroughly before the next step.

4 Trim about ⅜ inch (9.5 mm) off the top and bottom edges of the catalog page using pinking shears. Center and glue the page down on the card front. Roll thoroughly with the brayer.

5 Arrange the floral pieces and seed packet so they cascade down the card, overlapping each other. Glue them down one at a time, rolling with the brayer after each placement.

6 Measure in ½ inch (1.3 cm) from the right-hand edge of the card front, and then mark pencil dots at the 4 and 4½-inch (10.2 and 11.4 cm) points from the top of the card. Punch a ⅛-inch (3 mm) hole directly over each pencil mark through the front of the card only.

7 Thread the plaid ribbon through both holes from front to back. Loop it through the holes again to form a puffy "knot," and trim each ribbon end in a "V." Tape both ends down with double-sided tape.

8 Use a small dab of industrial glue to attach the charm to an empty spot on your collage.

9 Attach the seed beads one at a time so they appear to spill out of the open end of the seed packet. Use tiny dots of glue from a fine-tipped applicator.

I love using vintage papers as backgrounds—they add depth and a sense of history to cards. Sheet music, maps, newspapers, or old book pages all make great backgrounds.

In *Rose Boxes* (page 106) I used the entire page of a French philosophy book, while in *Shakespeare's Map* (page 102) I tore strips from an old map of England and alternated them with striped paper. Patterned papers can introduce an element of color to your background and lend a "wallpaper" effect to a scene. You can also make your own backgrounds with rubber stamps. Large stamps featuring crackle patterns, florals, script, or calligraphy create a quick background, while smaller stamps can be applied in repeat patterns. I like using a watermark stamp pad (a pad that uses a unique clear ink) to go just a shade darker than the base paper. Sometimes I will stamp out a darker print first, then stamp a paler, subtler image on the page. Just remember, a background should tie elements together rather than be the focus of your card.

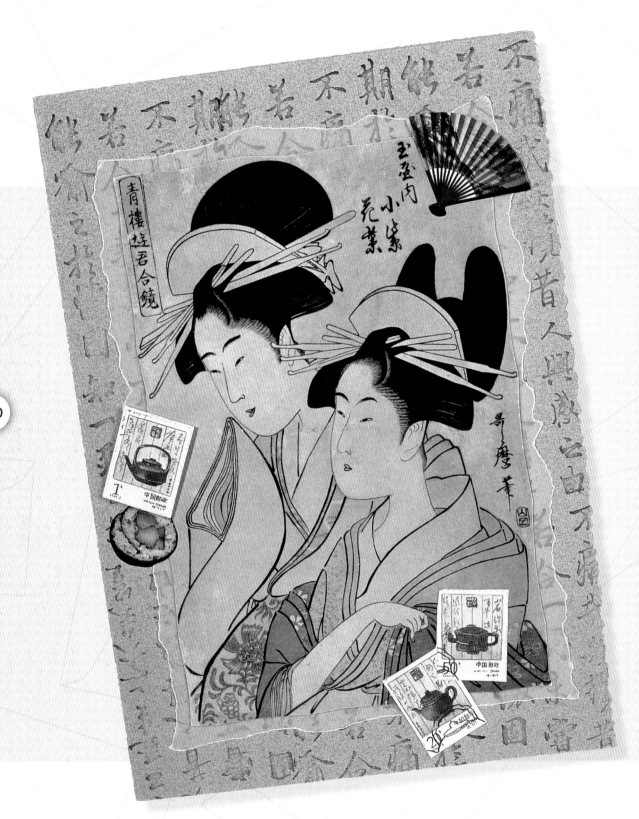

Japanese Ladies

As serene as a Japanese garden, the gently stamped calligraphy background, muted by a hand-torn vellum layer, lends a subtle and serene air to these elegant Japanese ladies.

MATERIALS

- 7 x 10-inch (17.8 x 25.4 cm) piece of speckled sage-green cardstock
- Large calligraphy rubber stamp
- Black ink pad
- Asian postcard
- 4½ x 6½-inch (11.4 x 16.5 cm) piece of heavy vellum paper
- 4 to 5 small Asian-themed pictures or stickers

NOTE

See page 116 for inside treatment ideas.

■ STEP BY STEP

1 Fold the cardstock to make a 5 x 7-inch (12.7 x 17.8 cm) card.

2 Ink the calligraphy rubber stamp with black ink. Stamp it out once on scrap paper, then stamp it onto the face of your card. Repeat this process to create an all-over pattern on the card. Try to line up the writing without overlapping.

3 Use deckle-edged scissors to trim ¹⁄₁₆ inch (1.6 mm) off the right-hand edge of both the front and back of the card.

4 Lightly trace the postcard shape onto the vellum. With your ruler, draw a second line ¼ inch (6 mm) beyond each side of the postcard to serve as a guide. Next, carefully tear off all four edges of vellum to create a ¼-inch (6 mm) torn border all around the postcard.

5 Glue your postcard to the center of the vellum and roll with a brayer, and then attach the entire assemblage onto the center of the card.

6 Scatter the smaller pictures and stickers around your central image and then glue them down.

Shakespeare's Map

Imagine winding your way down a quaint English road, retracing the steps of the Bard. Vintage maps make wonderful graphic backgrounds, their detailed geography telling visual stories of faraway people and places.

MATERIALS

- 7¾ x 10-inch (19.7 x 25.4 cm) piece of buff-colored cardstock
- ½ x 7¾-inch (1.3 x 19.7 cm) strip of brown striped paper
- 4 x 7¾-inch (10.2 x 19.7 cm) section of an English map
- 2½ x 7¾-inch (6.4 x 19.7 cm) piece of brown striped paper
- 7 brown-toned stamps, preferably British
- 2 small pieces of landscape or seafaring art in sepia tones
- Compass or other nautical rubber stamp
- Black ink pad
- Round brass charm

■ STEP BY STEP

1 Fold the cardstock to make a 7¾ x 5-inch (19.7 x 12.7 cm) card.

2 Trim ⅛ inch (3 mm) off the bottom horizontal front edge of the card.

3 Tear off one long edge of the ½ x 7¾-inch (1.3 x 19.7 cm) strip of brown striped paper. Glue it along the bottom edge of the inside of the card to create an inner border.

4 Carefully make a tear clear across your section of map, following the map's coastline (if applicable).

5 Tape the larger piece of striped paper behind the entire horizontal tear on the uppermost piece of map, making sure the stripes are straight. Glue both pieces down on the card face, lining them up with the top fold of the card.

6 Using the torn edges as a guide, glue the bottom half of the map to your card so it is even with the lower trimmed edge. There should be a gap between the two map pieces where the striped paper is visible. Roll the entire card face flat with a brayer.

7 Glue your stamps and pictures to the card, following the coastline or towns as if they were points of interest on a Shakespearean map.

8 Ink the compass stamp with the black ink pad, and stamp it out once on scrap paper to soften the color. Stamp it once or twice where there are open spaces in your collage.

9 Spread a small portion of industrial glue on the back of the brass charm, and press it down firmly onto the card.

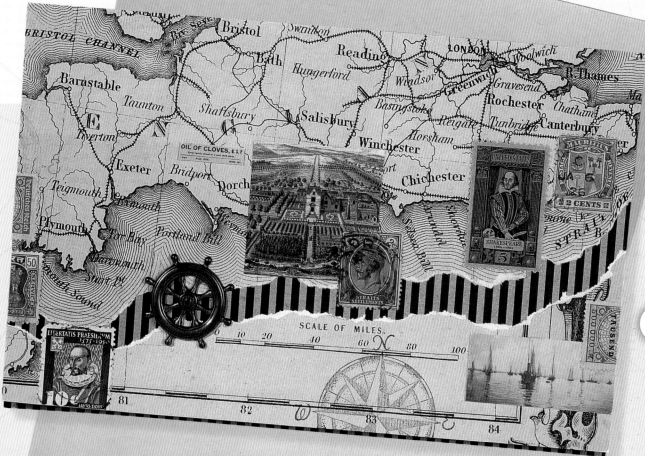

Dress Pattern

Reach underneath the thread and bobbins in your old sewing box for those used dress patterns! The mellow tea-colored tissue paper and interesting arcs and arrows create a layered background that can have either a modern or nostalgic look.

MATERIALS

- 8 x 11-inch (20.3 x 27.9 cm) piece of parchment-colored cardstock
- Several pieces of old dress pattern tissue
- Dress template (page 125)
- 5 x 5½-inch (12.7 x 14 cm) piece of neutral-colored scrap cardstock
- Black colored pencil
- Diamond pattern rubber stamp
- Black ink pad
- 2 scraps of patterned paper, about 3½ x 4½ (8.9 x 11.4 cm) inches each
- 2½ inches (6.4 cm) of patterned ribbon, ½ inch (1.3 cm) wide (for dress sash)
- Adhesive foam dots
- 12 inches (30.5 cm) of tan grosgrain ribbon, ⅝ inch (1.6 cm) wide
- 20 inches (50.8 cm) of thin ribbon or cord

STEP BY STEP

1 Fold the parchment-colored cardstock to make a 5½ x 8-inch (14 x 20.3 cm) card.

2 Layer and then glue pieces of the dress pattern over the front and back surfaces of the card. After you glue each piece down, roll over it with a brayer.

3 Trace the template provided on page 125 onto the piece of scrap cardstock, and cut it out.

4 Trace and shade some portions of the dress pattern tissue on your card with the black colored pencil to add to the depth of the background.

5 Randomly stamp diamonds on the card face in sections where the dress pattern is less interesting.

6 Using the cardstock template, trace the dress from the waist up on one piece of decorative paper, and the skirt portion onto another. Cut them both out and glue them to the cardstock template. Roll the template with the brayer.

7 Rub all the cut edges of the dress with the black ink pad. Let dry.

8 Wrap the short, patterned ribbon around the waist of the dress to form a sash. Attach the ribbon to the back of the dress with pieces of double-sided tape.

9 Place foam dots on the back of the dress at cuffs, shoulders, waist, and hem. Attach the dress to the lower center of the card, about 2 inches (5 cm) down from the top.

10 Using pinking shears, trim ¼ inch (6 mm) off both the top and the bottom edges of the entire card, front and back. Do not trim the side edge.

11 Measure down 1 inch (2.5 cm) from the top of the card spine, and use a mat knife and ruler to cut a ½-inch (1.3 cm) slot along the card spine.

12 Thread the tan ribbon through the slot so that both ends are on the inside of the card. Pull taut and tack one end down with double-sided tape, then tape the other end over the first one, trimming the loose end at a slant.

13 Wrap the thin ribbon around the right-hand side of the card, tying it in a simple knot on the front and leaving the ends to dangle.

NOTE

Here is a second version of a card using the same dress pattern, but this one has a Victorian feel due to the images chosen for the collage.

Rose Boxes

Rose-wrapped presents from a secret admirer in French Class 101? An entire page torn from an old foreign language textbook can create a simple yet effective background. Novels, poetry, history, and even dictionaries all make great choices.

MATERIALS

- 8½ x 11-inch (21.6 x 27.9 cm) piece of pale pink cardstock
- 5 x 8-inch (12.7 x 20.3 cm) page of French text
- 5 scraps of rose-printed paper, 2 x 4 inches (5 x 10.2 cm) or smaller
- 4 x 7½-inch (10.2 x 19 cm) piece of plain white cardstock
- 2 feet (61 cm) of pink seam binding or silk ribbon
- Adhesive foam dots
- ⅛-inch (3 mm) hole punch
- White jeweler's tag
- Dusty pink ink pad
- Small alphabet rubber stamp set
- Ecru-colored ink pad
- 10 inches (25.4 cm) of pink embroidery floss

■ STEP BY STEP

1 Fold the pink cardstock to make a 5½ x 8½-inch (14 x 21.6 cm) card.

2 Trim the three open sides of the card with large scalloped scissors. Use a single scallop of the scissors to round off each of the right-hand corners.

3 Trim the text page so it is approximately ¼ inch (6 mm) smaller on each side than your card.

4 Center and glue the page down, and roll flat with a brayer.

5 Cut out five rose patterned rectangles in five different sizes. Stack them centered, and in descending height, and then glue them onto the piece of white cardstock. Roll all with the brayer.

6 Trim out the stack of boxes as one piece.

7 Cut an 8½-inch (21.6 cm) piece of pink ribbon and wrap it around your box stack, securing the ribbon ends on the back with pieces of double-stick tape.

8 Place foam dots on the back corners of the box stack. Line the stack up with the center

bottom border of the page of text and stick it down.

9 Punch two ⅛-inch (3 mm) holes, ½ inch (1.3 cm) apart, at the top center of the stack.

10 Stamp two short words on the jeweler's tag with the dusty pink ink pad. Be sure to stamp on the mat side or they will rub off! Use the ecru ink pad to antique the edges of the tag.

11 Remove the tag's white string and replace it with pink floss, tying the loose ends together in a knot.

12 Thread the remaining ribbon from back to front through the punched holes. Loop the tag's pink string over one ribbon end, then tie the ribbon into a bow on the front, above the stack of rose boxes. Trim both ribbon ends in a deep "V."

Mi Familia

Music reminds me of my Grandpa (pictured here) who loved to play the accordion and sing at family gatherings. Deep in the piano bench, yellowing sheet music awaits new life as the perfect card background.

BACKGROUNDS

MATERIALS

- 7¾ x 11-inch (19.7 x 27.9 cm) piece of rust-colored cardstock
- 5½ x 7¾-inch (14 x 19.7 cm) piece of old sheet music
- Sepia-and taupe-colored ink pads
- 2 pieces of 2½ x 6-inch (6.4 x 15.2 cm) different red patterned papers
- 5 x 6-inch (12.7 x 15.2 cm) piece of off-white cardstock
- Heart template (page 124)
- 4½-inch-square (11.4 cm) piece of a light-colored patterned vellum
- 3 small copper eyelets
- Heavily tarnished brass button or charm
- 12 inches (30.5 cm) of brown embroidery floss
- ¾ x 2½-inch (1.9 x 6.4 cm) scrap of off-white cardstock
- Rubber stamp alphabet set
- 2 or 3 sepia-toned photographs, each approximately 2 x 3 inches (5 x 7.6 cm)

▄ STEP BY STEP

1 Fold the rust-colored cardstock in half to make a 5½ x 7¾-inch (14 x 19.7 cm) card.

2 Tear off a very small edge from each side of the sheet music.

3 Brush all the torn edges of the sheet music with the taupe stamp pad for an antiqued look.

4 Glue the sheet music down to the center of the card face, and roll with a brayer.

5 Tape the two pieces of patterned paper together along their 6-inch (15.2 cm) edges. Glue this joined piece of paper to the 5 x 6-inch (12.7 x 15.2 cm) piece of off-white cardstock, and roll with the brayer.

6 Trace the heart template (page 124) onto the patterned paper, lining up the paper seam with the center points of the heart. Cut out the heart and brush all the cut edges with the taupe-colored ink pad.

7 Trace the pointy end of the heart onto the vellum, and cut it out. Cut straight across the top of the partial heart with scallop-edged scissors to form a triangular shape.

8 Attach very thin strips of double-sided tape along each straight edge (not the scalloped edge) of the back of the vellum triangle. Line up the vellum piece with the cutout heart shape and press them together, forming a pocket.

9 Set the three copper eyelets, one through each corner of the vellum pocket.

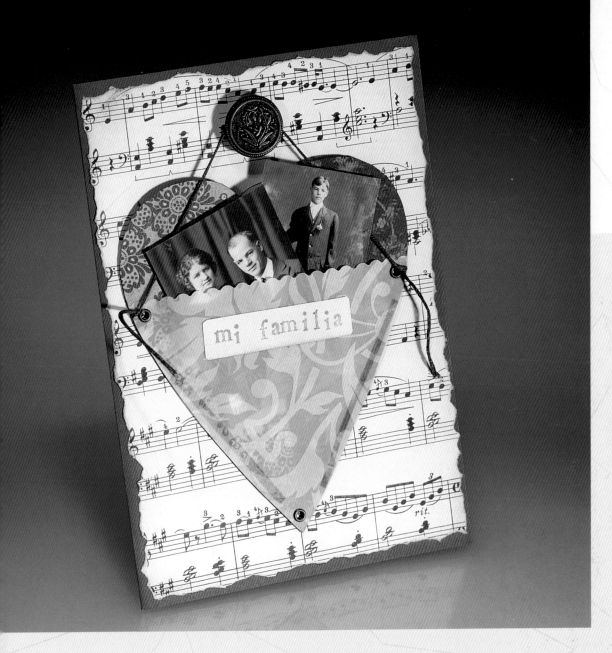

10 Using a generous dab of industrial glue, attach the brass charm 1 inch (2.5 cm) down from the top center of the card. Let it dry thoroughly.

11 Tie one end of the brown embroidery floss through one of the side eyelets. Drape the floss over the button, then thread the floss through the opposing eyelet. Pull it snug (but not taut), then tie it off in a knot.

12 Brush each edge of the smaller off-white cardstock piece with the taupe ink pad, and then use sepia ink to stamp out "mi familia" (my family) or another sentiment. Tape this piece to the upper center of the vellum pocket, and place your photos in the pocket.

NOTE

This heart pocket card also makes a lovely pink or red valentine. Created in pale pink or blue, it's a sweet way to send out a new baby photo.

Blue Willow Bear

One lump or two? The crisp blue and white all-over pattern of a large crackle stamp ties together the beloved icons of a teddy bear and tea. Card and bear are both decorated with a coordinating ribbon.

MATERIALS

- 6 x 12-inch (15.2 x 30.5 cm) piece of white cardstock
- Large crackle pattern rubber stamp
- Dark blue ink pad
- 6 pictures of blue and white china (catalogs are a good source)
- Picture of a teddy bear
- 20 inches (50.8 cm) of striped blue and cream ribbon, ⅜ inch (9.5 mm) wide

■ STEP BY STEP

1 Fold the white cardstock in half to make a 6-inch-square (15.2 cm) card.

2 Ink the crackle stamp with blue ink, and stamp the entire front and back of the card.

3 Using deckle-edged scissors, trim ¼ inch (6mm) off the right-hand edge of the card face.

4 Carefully cut out around the bear and the blue and white china pictures.

5 Arrange and glue down the china and bear pictures. To place the bear inside the bowl, cut a slit along the rim and tuck him in.

6 Use 7 inches (17.8 cm) of the ribbon to tie a very small bow. Attach it to the bear's neck with a generous dab of industrial glue.

7 Wrap the remainder of the ribbon around the inside right-hand edge of the card so that the ends are on the backside of the card. Attach the ribbon by placing thin strips of double-sided tape under the entire length.

8 If desired, glue a china picture to the inside of the card, nestled next to the ribbon.

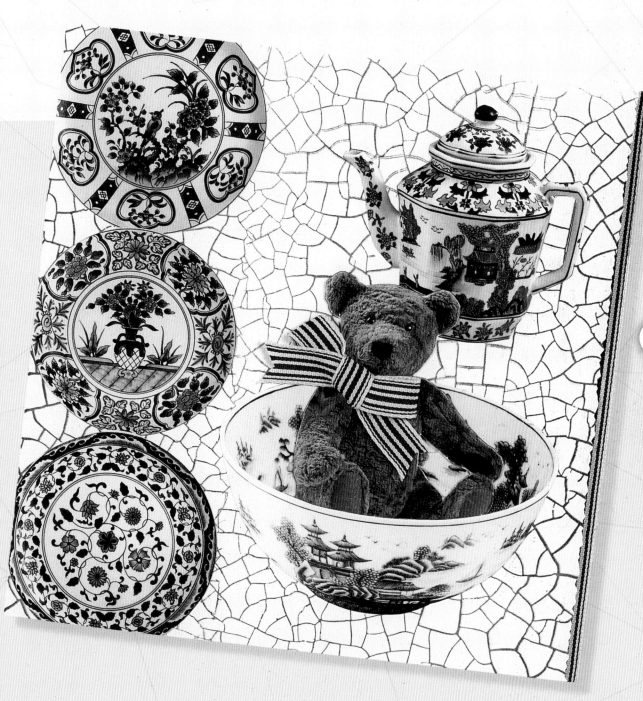

Cerises

Luscious cherries bursting with flavor, straight from the farm stand—what could be a better theme than gorgeous ripe fruit? This card uses different sized prints and labels, including a large one (muted by over coloring), as a background.

MATERIALS

- 7¾ x 11-inch (19.7 x 27.9 cm) piece of olive-green cardstock
- 5¼ x 7½-inch (13.3 x 19 cm) piece of red patterned paper
- 5½ x 7½-inch (14 x 19 cm) botanical illustration (cherries or other fruit)
- White or cream colored pencil
- 4 or 5 coordinating fruit labels or illustrations
- 2 feet (61 cm) of red and green ribbon, ⅝ inch (1.6 cm) wide
- Large tarnished gold charm
- Green fabric leaf

■ STEP BY STEP

1 Fold the green cardstock in half to make a 5½ x 7¾-inch (14 x 19.7 cm) card.

2 Glue the red patterned paper to the center of the card face, and roll with the brayer.

3 Tear off ¼ inch (6 mm) from each side of the botanical illustration.

4 Glue the botanical illustration to the center of the red patterned paper. If you like, scribble on the darker portions of the illustration with the white colored pencil to soften the art for the background.

5 Arrange three of the labels on the front, having one bleed off the edge. Glue them down one by one, and roll with the brayer.

6 Wrap the ribbon around the right-hand edge of the card so that both ends are on the card front. Stick down the upper end with double-sided tape. Double the other end back on itself to form a loop, and tape it down directly over the first piece of tape.

7 Place a generous dab of industrial glue to the back of the charm, and press one tip of the leaf into the glue. Press both pieces down on top of the taped area of the ribbon.

8 Arrange and tuck the remaining labels underneath the ribbon band on the inside of the card, and glue them down.

BACKGROUNDS

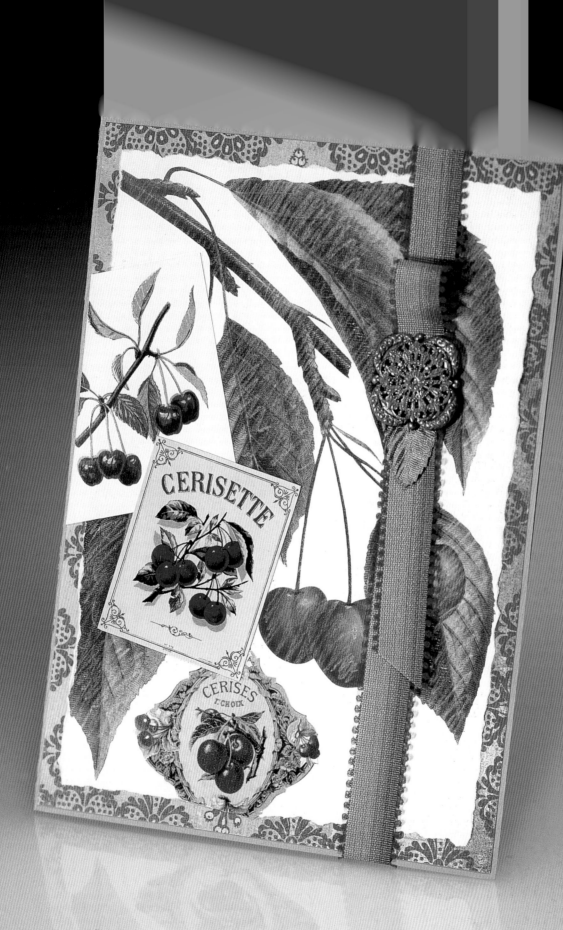

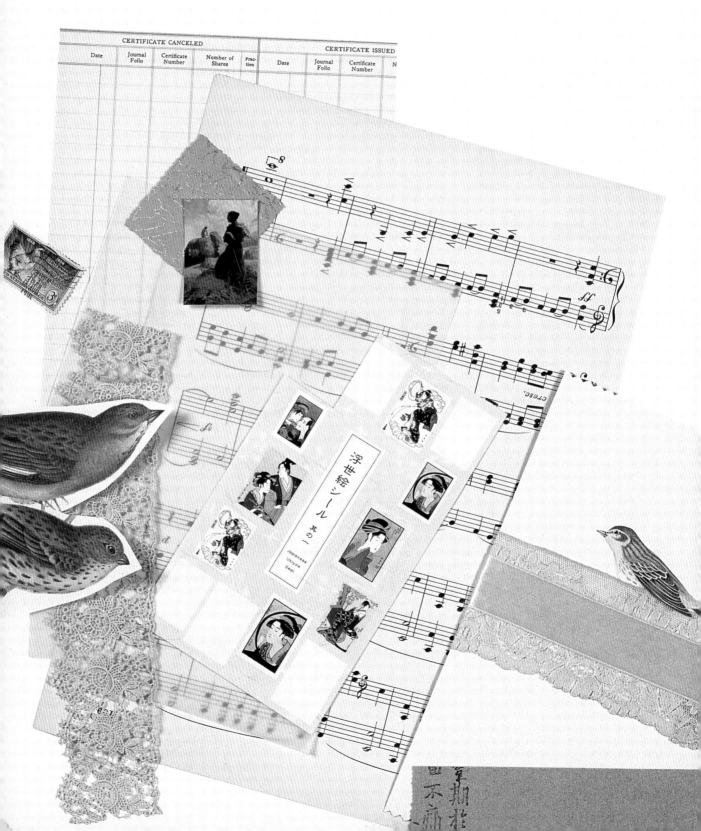

Everyone admires the front of a hand-made card, but what happens when the recipient opens it? Why not carry your design from the front to the inside of the card to make it even more memorable? It's easy and fun to pick out just a few little elements that have been used on the face of the card and repeat them within. For example, if you rubber-stamped the front, how about stamping one or two images on the inside? Or if stickers were used in your design, consider adding a few to the interior, letting them bleed off the card edges for a less formulaic look. Embellishments like a ribbon, that lie flat, can be used to add texture and interest (you'll see in *Oiseaux* on page 120, that I even attached a tiny feather). A square or rectangle cut out of the front cover becomes a window of opportunity, allowing you to decorate around whatever it reveals. Overall, the key to a well-designed inside treatment is to not overdo it, but to add a little surprise for the lucky recipient.

Japanese Ladies

A simple stamped border is a quick way to add excitement to any cardstock. Vellum frames set off images while allowing the underlying patterns to show through.

MATERIALS

- Asian character calligraphy rubber stamp
- Black ink pad
- Japanese-themed picture
- Scrap piece of vellum (large enough to mount the picture on)
- 3 additional small Japanese-themed stickers or pictures

NOTE

See page 100 for the front cover design of this card.

▪ STEP BY STEP

1 Lightly stamp the calligraphy-patterned stamp down both the left- and right-hand borders of the card.

2 Glue the largest image onto the vellum piece and tear all four sides of the vellum to form a ripped-edge border.

3 Arrange and then glue the vellum-framed picture and the smaller pictures over both of the stamped edges.

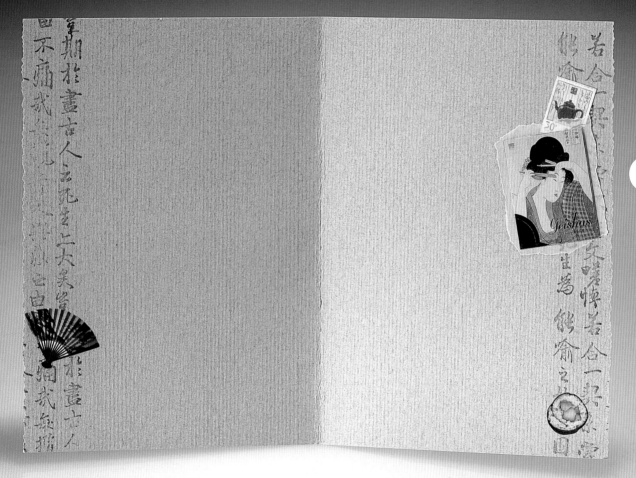

Golden Pears

When you open this card, you'll see a tiny work of art showcased through the gold-scalloped frame of a hand-cut window. The patterned paper around the window forms a diamond shape, making the card as attractive from the inside as from the outside.

MATERIALS

- 2 gold metallic paper strips, each ½ x 8½ inches (1.3 x 21.6 cm)
- 2 strips of script-patterned paper, each 1 x 8 inches (2.5 x 20.3 cm)
- Green-toned postage stamps
- Pear image or sticker

NOTE

See page 38 for the front cover design of this card.

STEP BY STEP

1 Glue the gold paper strips along the inside right- and the left-hand edges of the card.

2 Tear a small border off the long side of each script-patterned strip. Place it on top of the gold strip, leaving a thin strip of the gold showing (see the project photo). Glue it down and roll it with a brayer. Repeat on the other card edge.

3 Using the project photo as a guide, glue down the stamps and pear images. Trim off the excess.

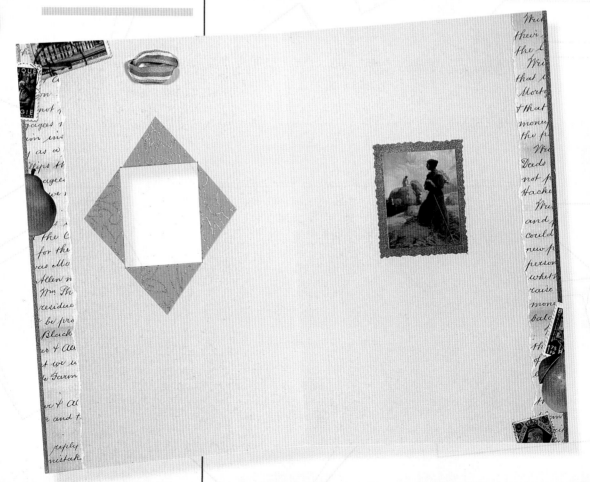

Pink Lady

Covering the entire inside of a card with patterned, complementary-colored paper adds interest and gives your images a nice background to play off of.

MATERIALS

- 8 x 11-inch (20.3 x 27.9 cm) piece of pink striped paper
- 1 x 8 inch (2.5 x 20.3 cm) strip of hot-pink vellum
- Rubber stamp of a woman's face
- Black ink stamp pad
- Scrap of hot-pink paper (large enough to stamp image)
- Pink postage stamps

NOTE

See page 16 for the front cover design of this card.

Paper should be applied before the ribbon is wrapped (see step 10, page 17).

■ STEP BY STEP

1 Glue the striped paper to cover the entire inside of the card. Roll thoroughly with a brayer and score the center for an easier fold.

2 Tear one very ragged edge from the long side of the vellum strip, and then glue it along the right-hand edge of the card. Roll it with the brayer.

3 Stamp the woman's face on the hot-pink paper and cut it out.

4 Using the project photo as a guide, arrange and then adhere the stamped face and postage stamps.

Oiseaux

Small pieces of bookkeeping paper and a tiny feather continue the bird theme from the front of this card to the inside. The lined bookkeeping paper makes an attractive and handy place to pen a note.

MATERIALS

- 2 pieces of bookkeeping paper
- 3 small bird pictures or stamps
- Tiny bird feather
- Bird rubber stamp
- Black ink pad

NOTE

See page 85 for the front cover design of this card.

STEP BY STEP

1 Tear narrow borders off all four sides of both pieces of the bookkeeping paper.

2 Glue the pieces of bookkeeping paper to the card inside (see the project photo).

3 Glue the small bird images above and below the bookkeeping paper pieces.

4 Stamp a bird image in one corner of the bookkeeping papers.

5 Use bonding adhesive to attach the tiny feather.

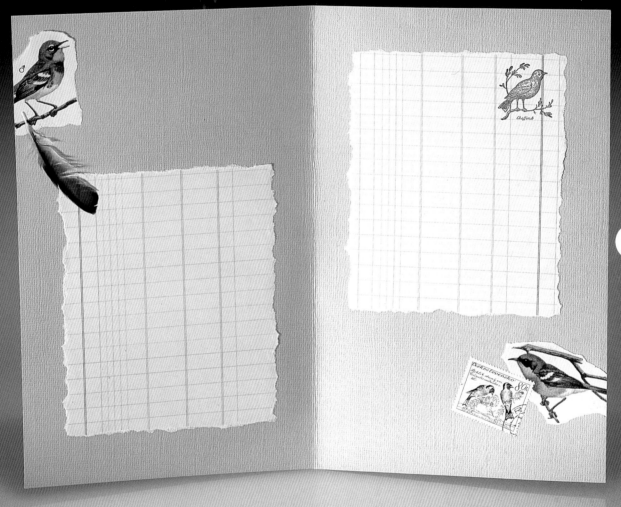

Song Bird

Just a couple of quick snips around a paper bird's wing and tail gives it the appearance of nesting among the ribbon and lends the card a pleasing three-dimensional quality.

MATERIALS

- 1 x 5½-inch (2.5 x 14 cm) piece of sheet music
- ½ x 8½-inch (1.3 x 21.6 cm) strip of black paper
- Bird image

NOTE

See page 66 for the front cover design of this card.

■ STEP BY STEP

1 Tear a narrow border off each 5½-inch (14 cm) side of the sheet music.

2 Glue the sheet music strip horizontally at the center of the right-hand side of the card.

3 Using pinking shears, cut the black strip of paper in half lengthwise.

4 Glue the black strip vertically on the right-hand edge of the card, trimming the ends off to match the pinked borders.

5 Cut out the bird and tuck him under the lace band with his wing and tail on the outside, and glue him down.

INSIDE TREATMENT

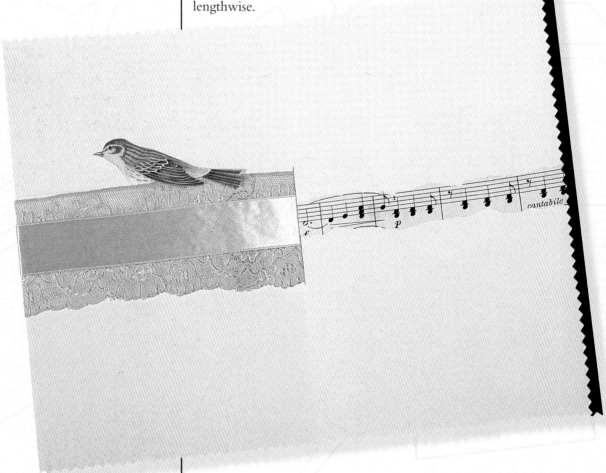

Dog Biscuits

Inside a card is the perfect space to feature a photo gallery of a favorite pet.
Decorative papers in playful patterns help express your pet's personality.

MATERIALS

- 4½ x 5-inch (11.4 x 12.7 cm) piece of orange patterned paper
- 2 smaller pet photos
- 3-inch square pet photo
- 4 x 4½-inch (10.2 x 11.4 cm) piece of multi-colored patterned paper

NOTE

See page 56 for the front cover design of this card.

■ STEP BY STEP

1 Using pinking shears, trim off ¼ inch (6 mm) from each edge of the patterned papers.

2 Carefully trim around the animals in the two smaller pet photos.

3 Glue the orange paper, at an angle, to the right-hand side of the card.

4 Glue the pet photo to the center of the multi-colored paper. Line up the photo behind the window so it's straight, and glue the assemblage on top of the orange paper.

5 Glue the smaller photos above and below the central photo.

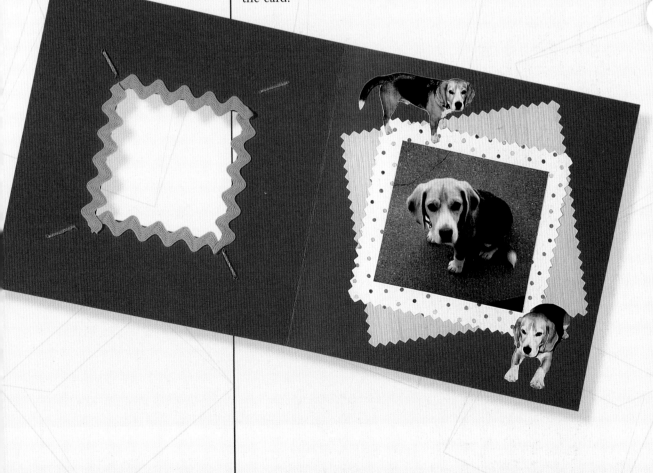

Templates

birthday flag

onesie

heart pocket

dress pattern

theater curtain

TEMPLATES

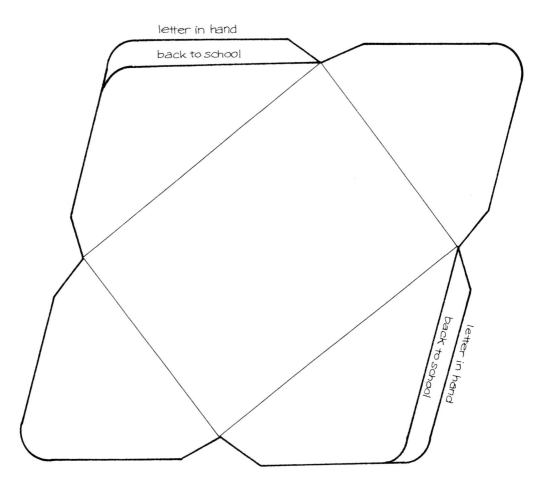

letter in hand

back to school

letter in hand
back to school

About the Author

Peggy Jo Ackley began her career as a greeting card designer and later expanded her designs into gifts and housewares. She is probably best known as the illustrator of the Bitty Bear book series for the American Girl Company. Since 2002, she has expanded her design work into the art of collage. Always encouraged by her parents, Peggy has been drawing and painting since age three. She has a degree in fine art from the University of California at Davis and currently makes her home in Marin County, California, with her husband and teenage son.

Acknowledgments

I would like to thank Ronnie Sellers of Sellers Publishing, Deborah Michel of Michel Design Works, and Wayne and Linda Bonnett of Windgate Press for kindly granting me permission to use their wonderful images.

Index

Acknowledgments, 127

Adhesives

 Double-sided tape, 7

 Foam dots, 7

Animal-themed, 14, 56, 66, 68, 76, 82, 84, 86, 92

Backgrounds, 100, 102, 104, 106, 108, 110, 112

Birthday cards, 50, 64

Bone folders, 8, 10

Brayers, 8, 11

Buttons, 34, 78, 82

Color themes, 14, 16, 18, 20, 22, 24, 26, 28

Decorative-edged scissors, 8

Embellishments, 64, 66, 68, 70, 72, 74, 76, 78

Embossing, 9

Eyelets, setting, 10

Focal points, 32, 34, 36, 38, 40, 42

Folding, 10

Fruit-themed, 28, 38, 112

Gatefold cards, 16, 26

Glue

 Bonding, 7

 Craft, 7

 Industrial strength, 7

 Stick, 7

Gluing surfaces, 7

Inside treatments, 116, 118, 119, 120, 122, 123

Knife, mat or craft, 8

Photographs, 46, 48, 50, 52, 54, 56, 58, 60

Photos, sources, 45

Postage stamps, making, 59

Scoring, 10

Tag cards, 68

Tearing, 11

Techniques, 9

Themes, 82, 84, 86, 88, 90, 92, 94, 96

Tool kit, 7

Wedding cards, 54

Window cards, 18, 38, 46, 50, 56, 70, 86, 90